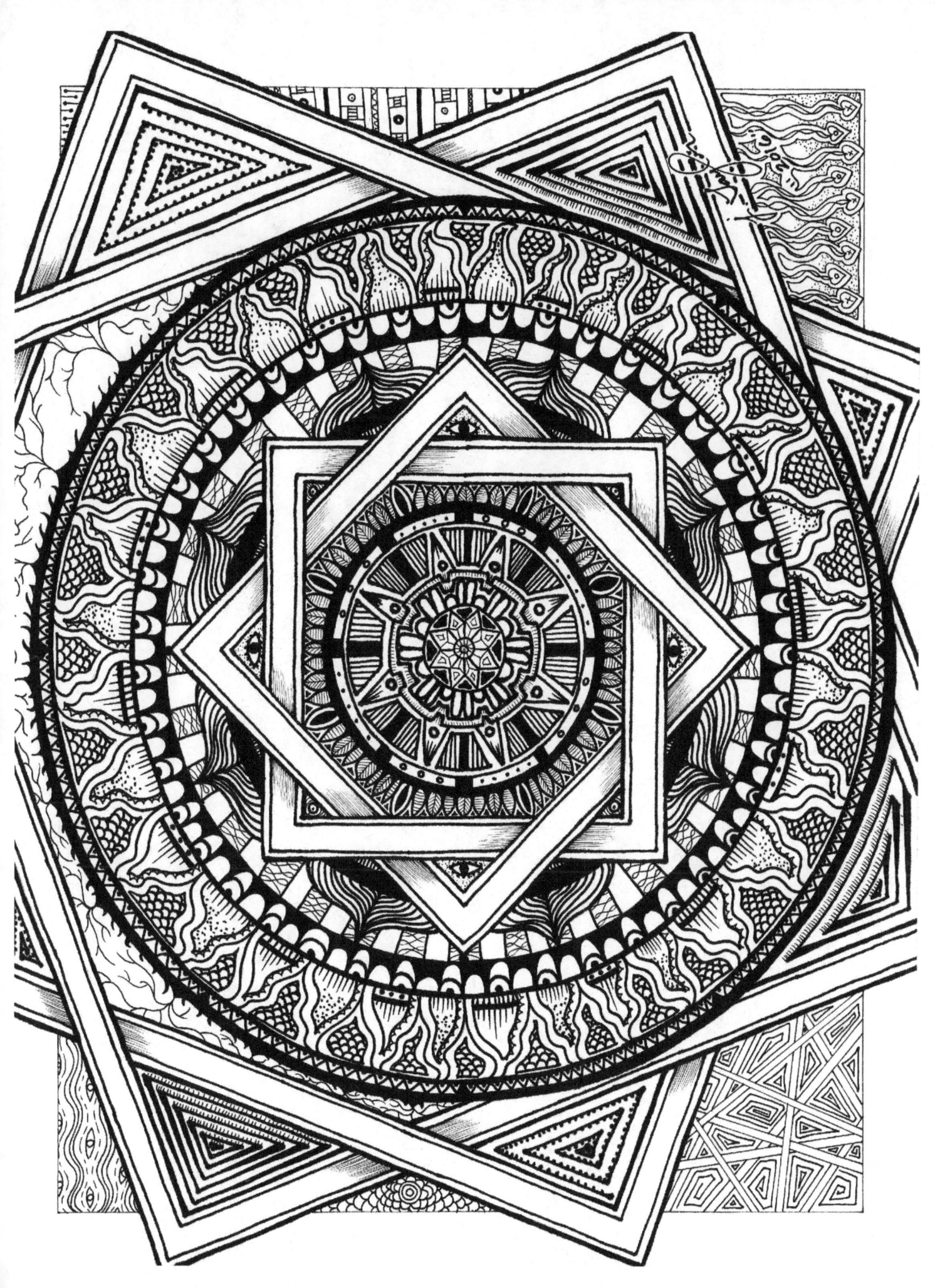

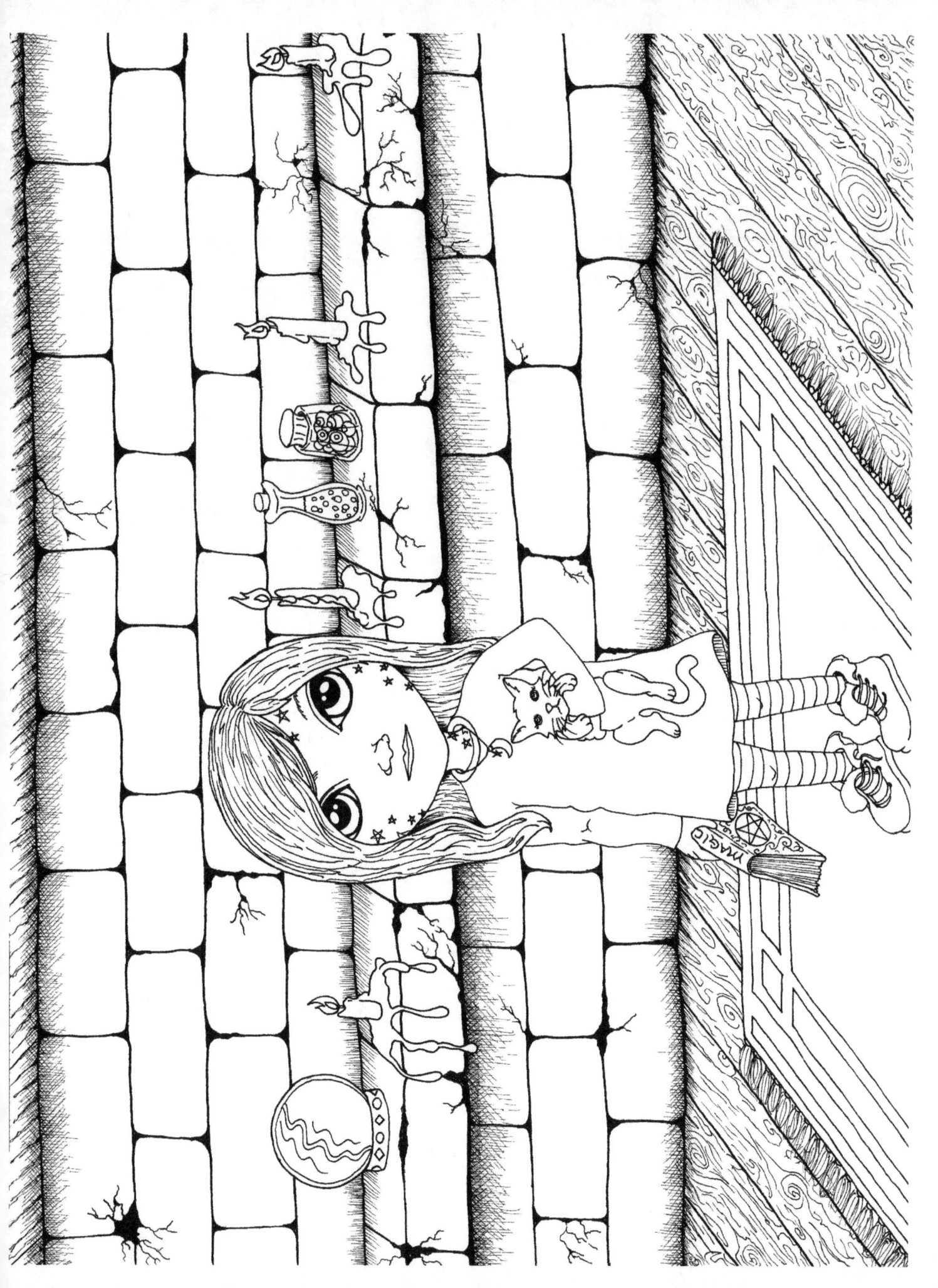

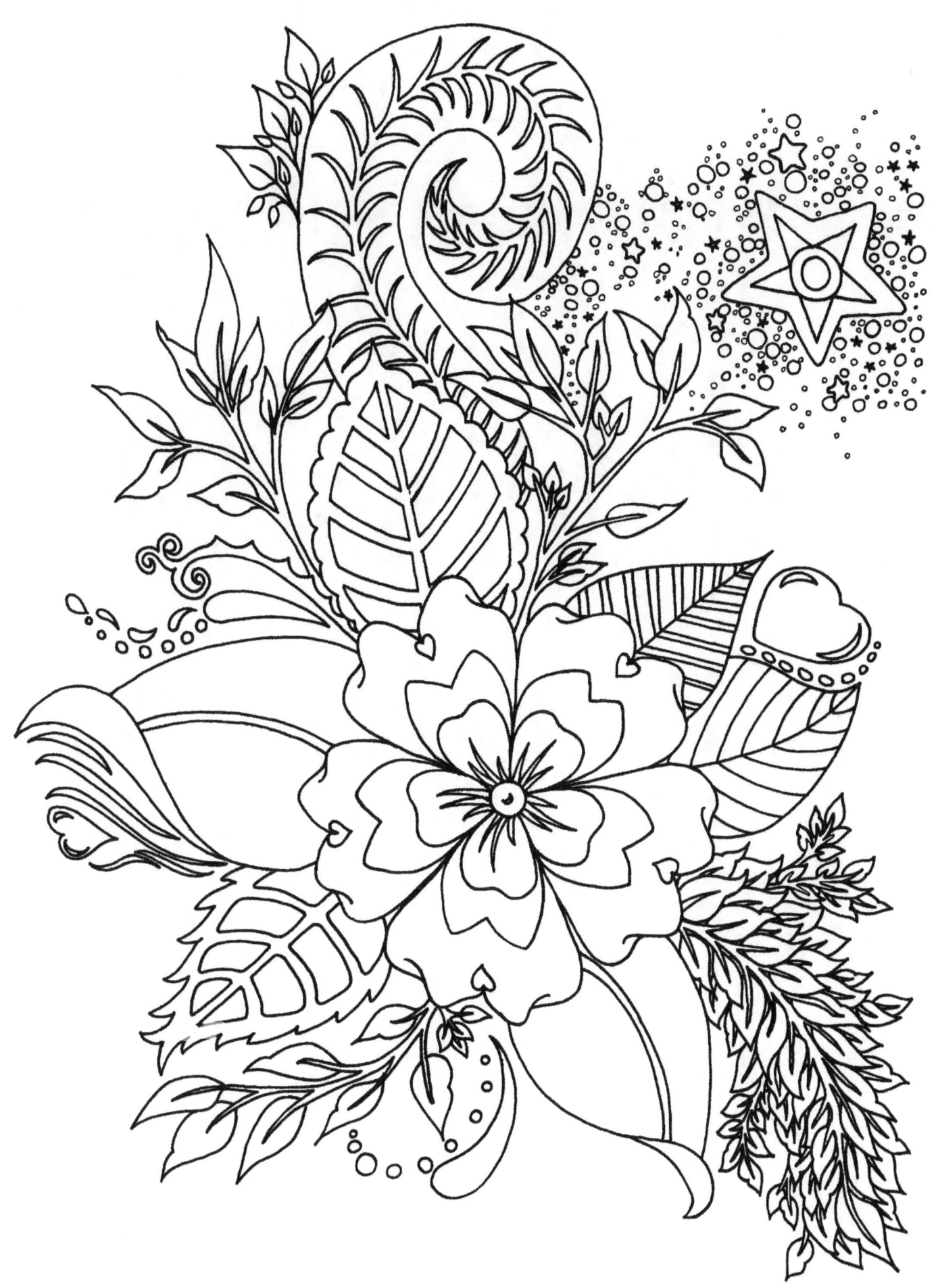

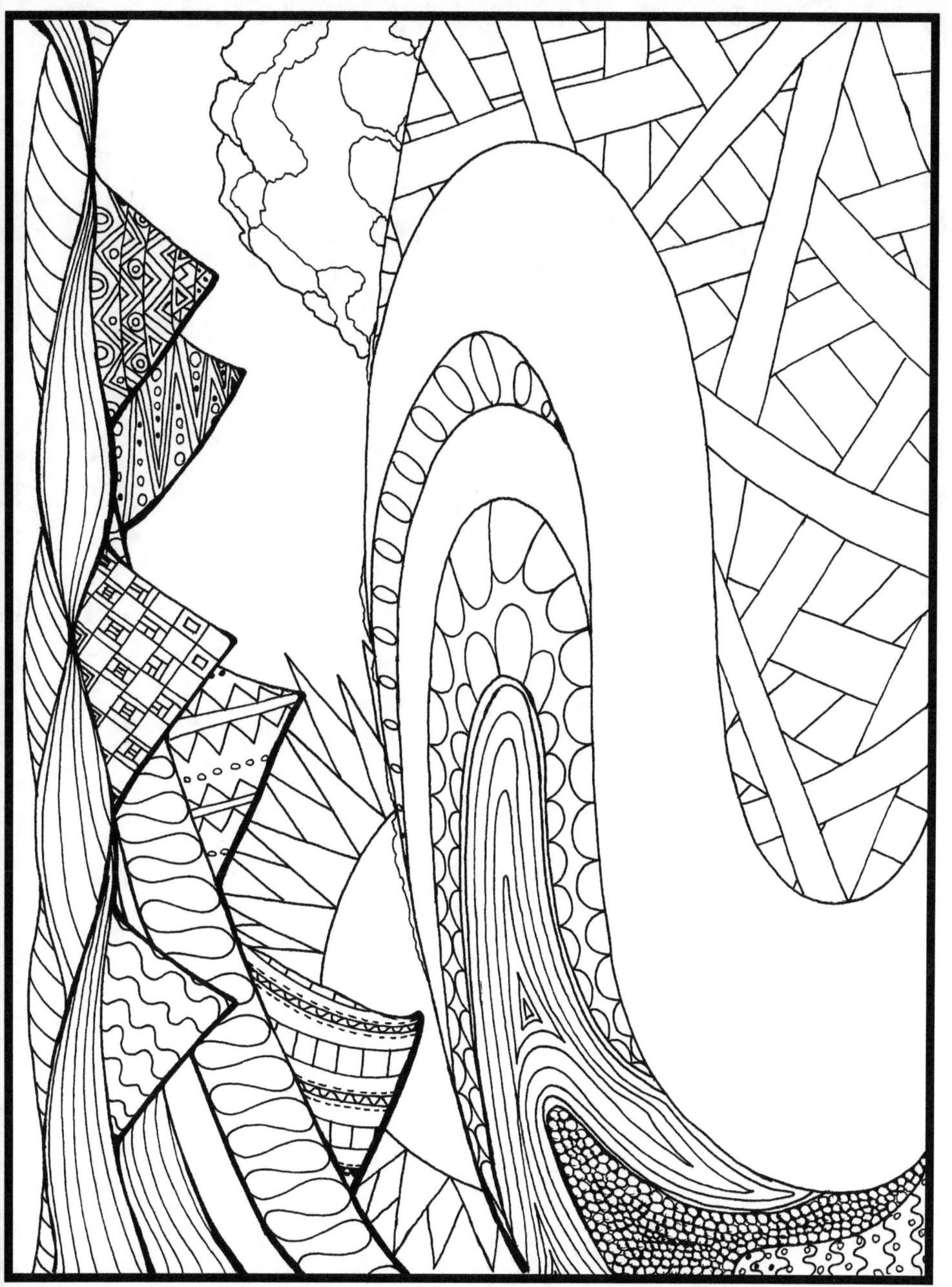

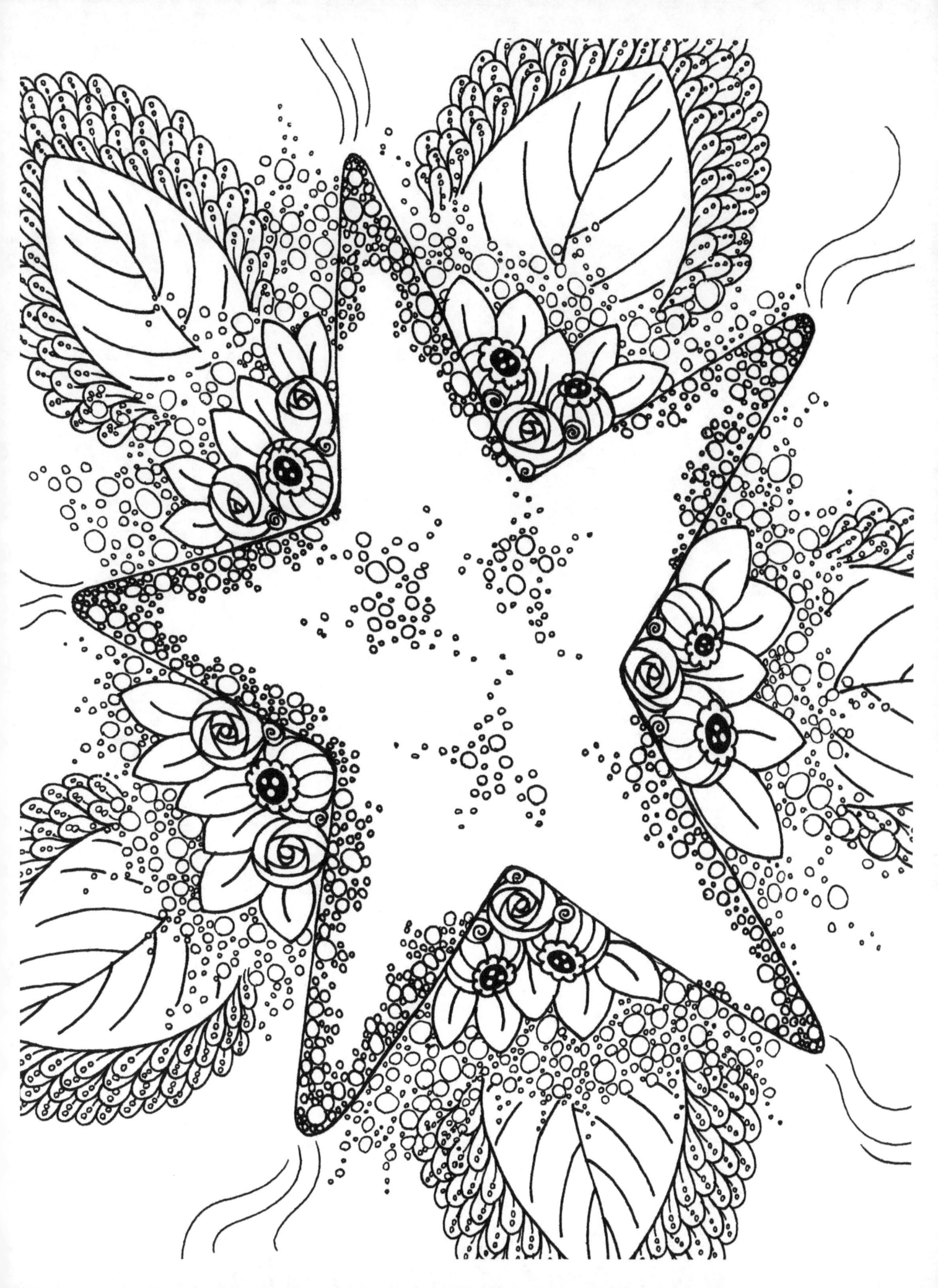

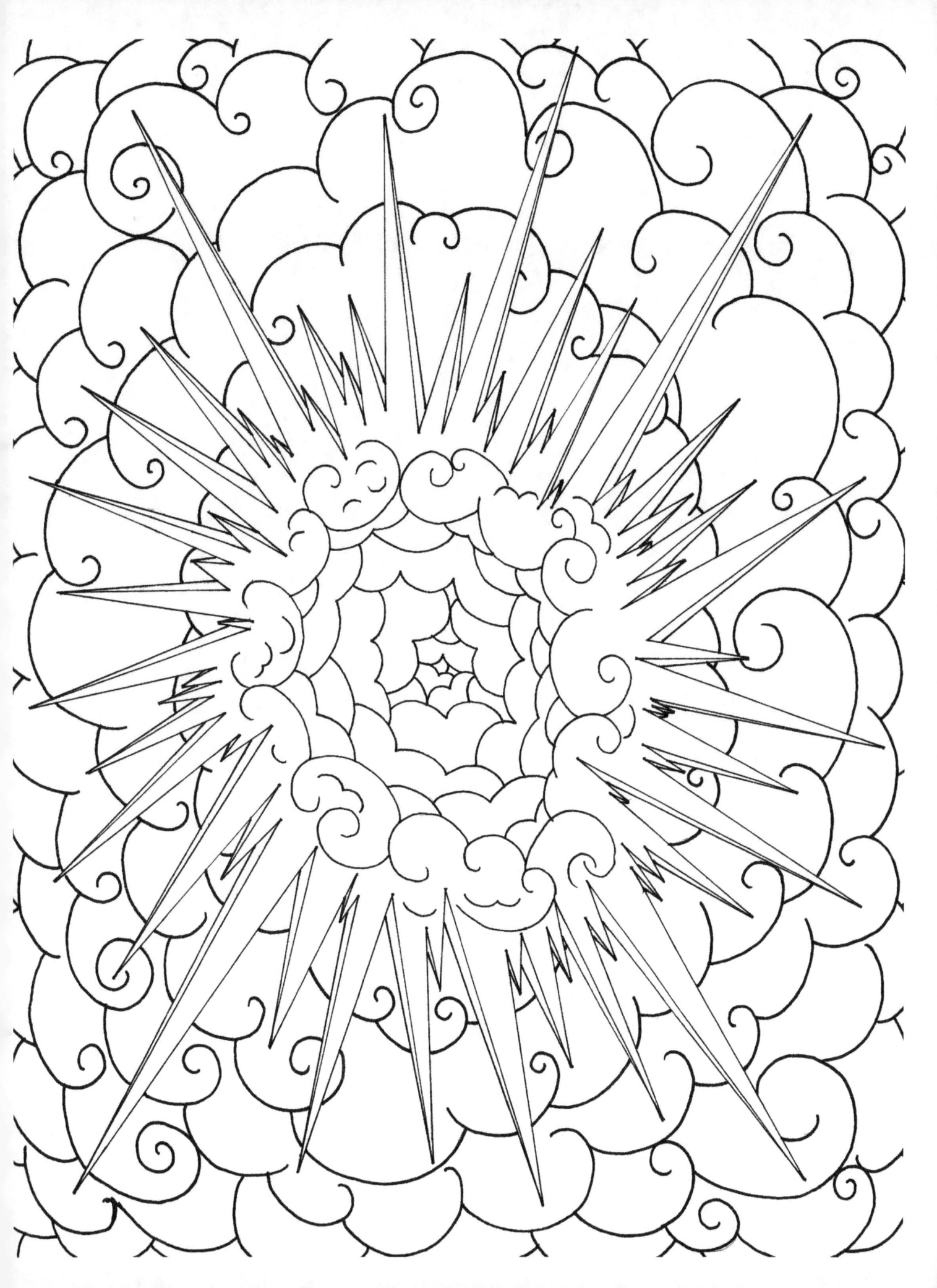

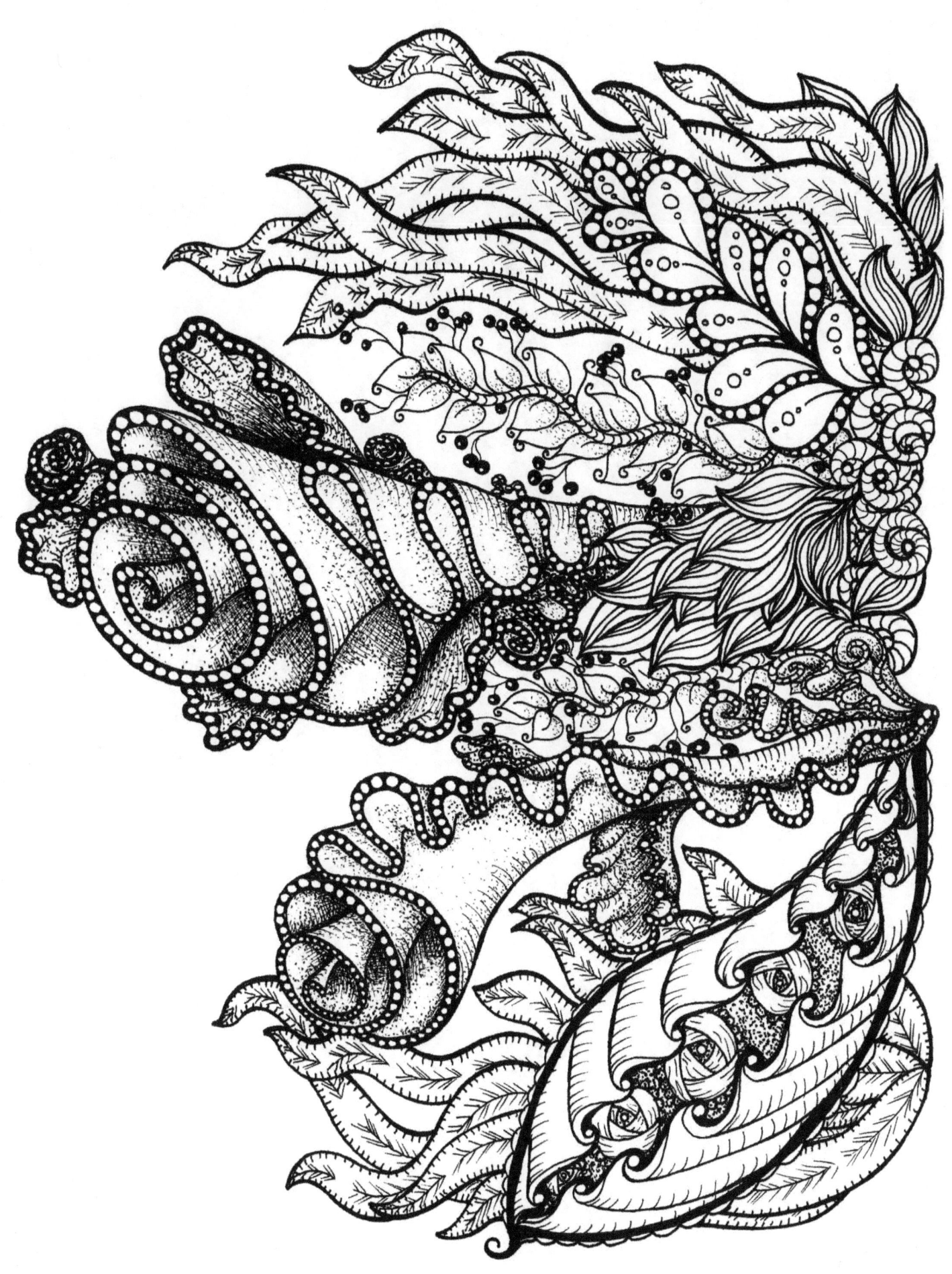

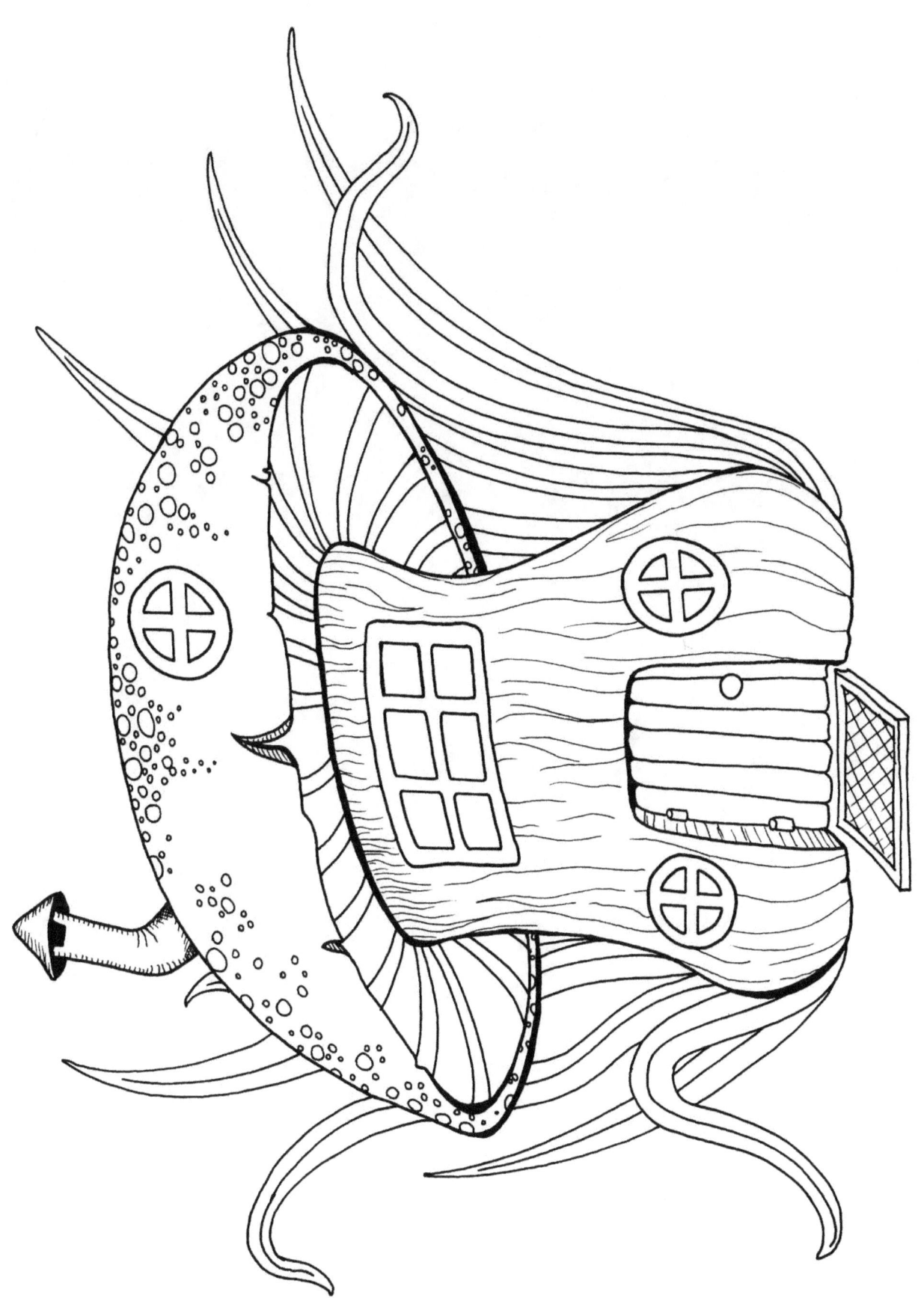

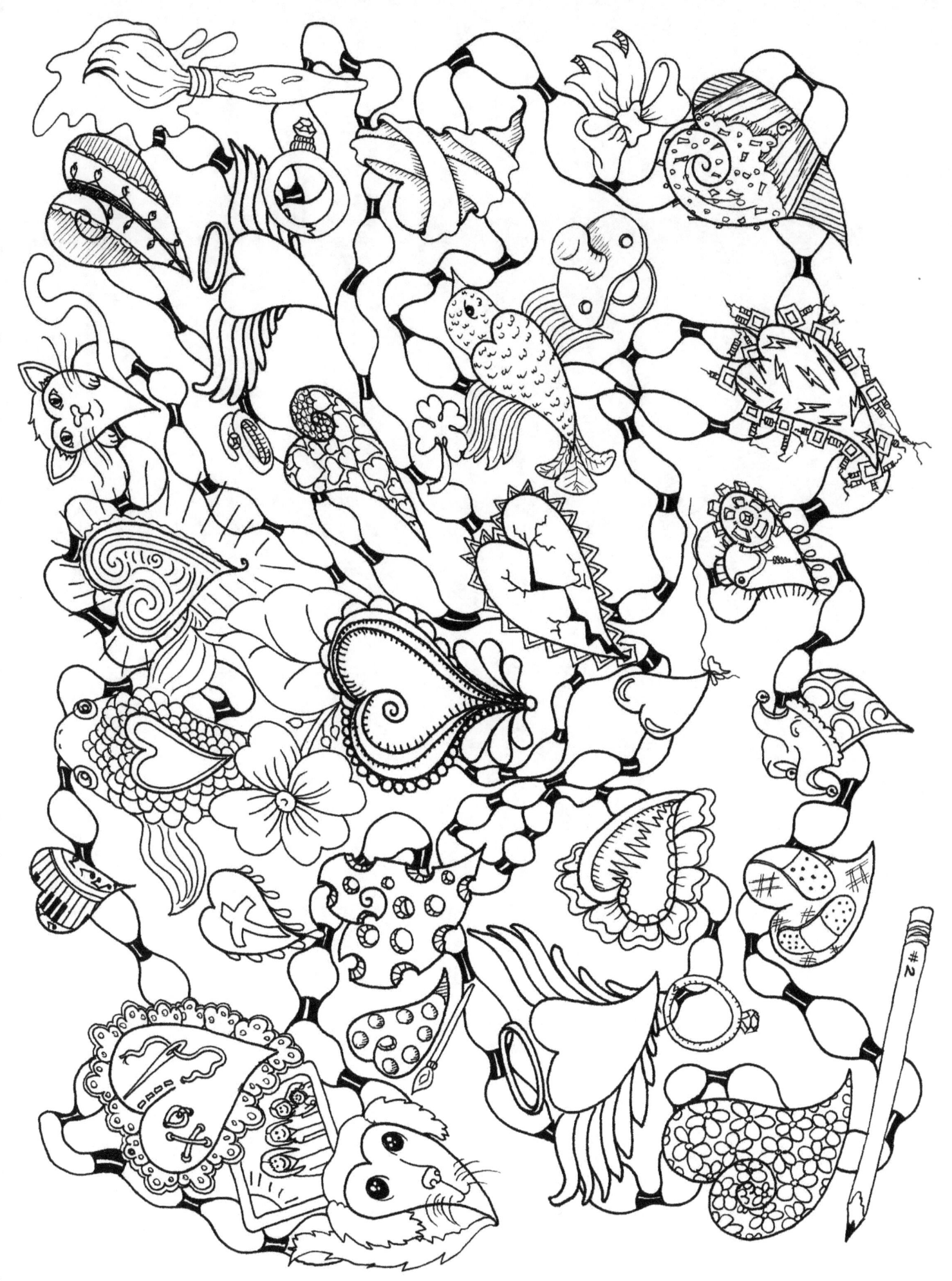

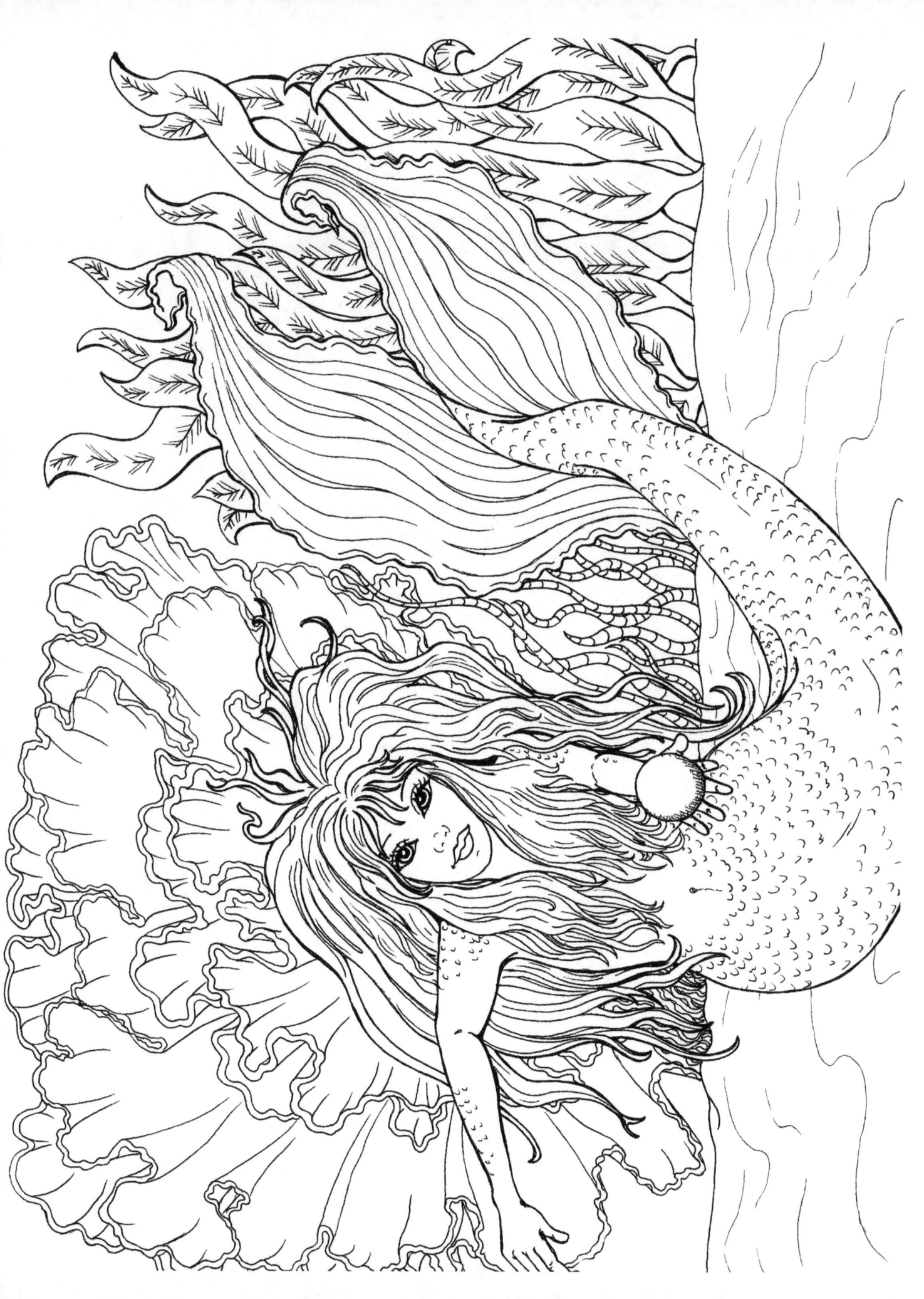

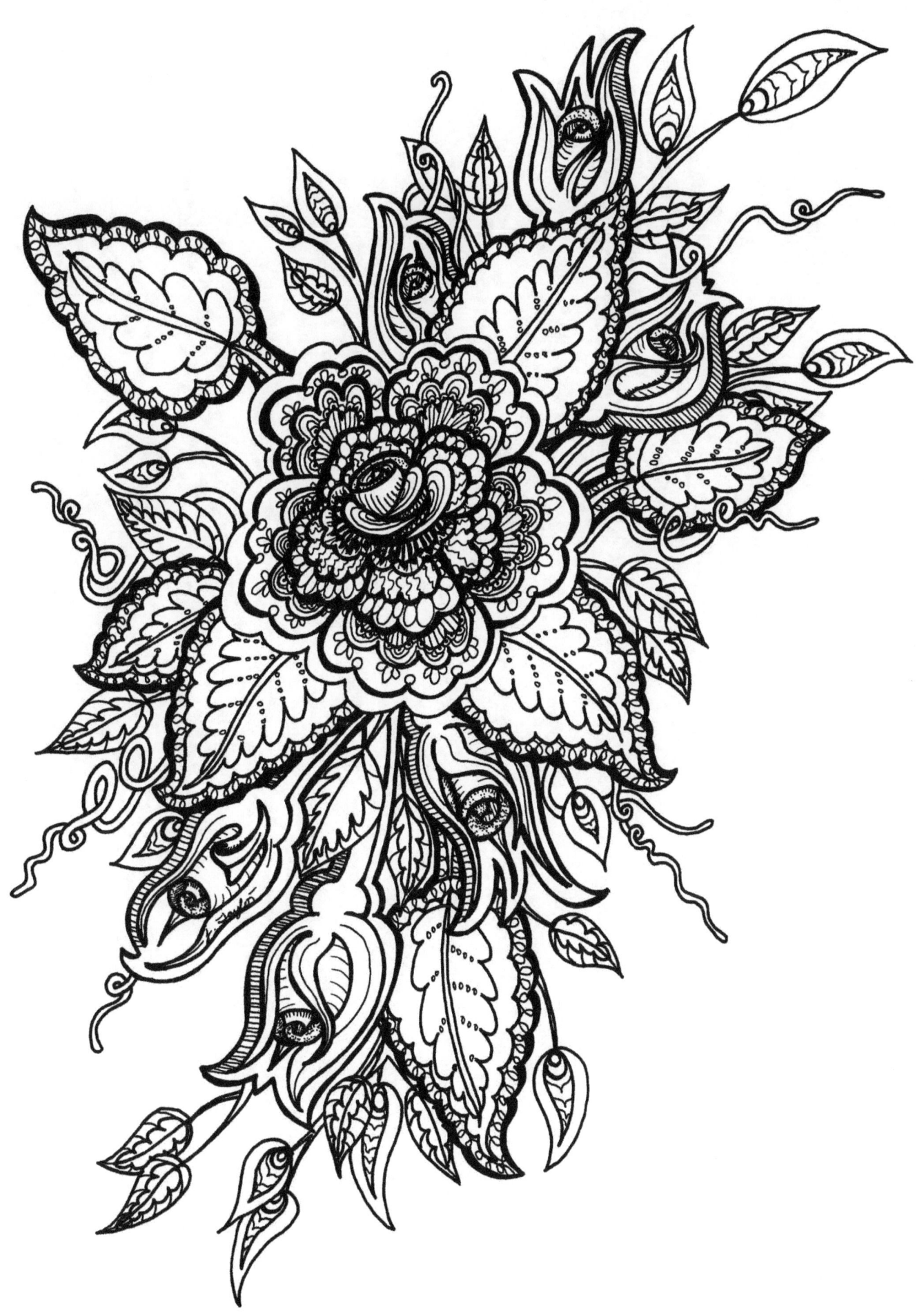

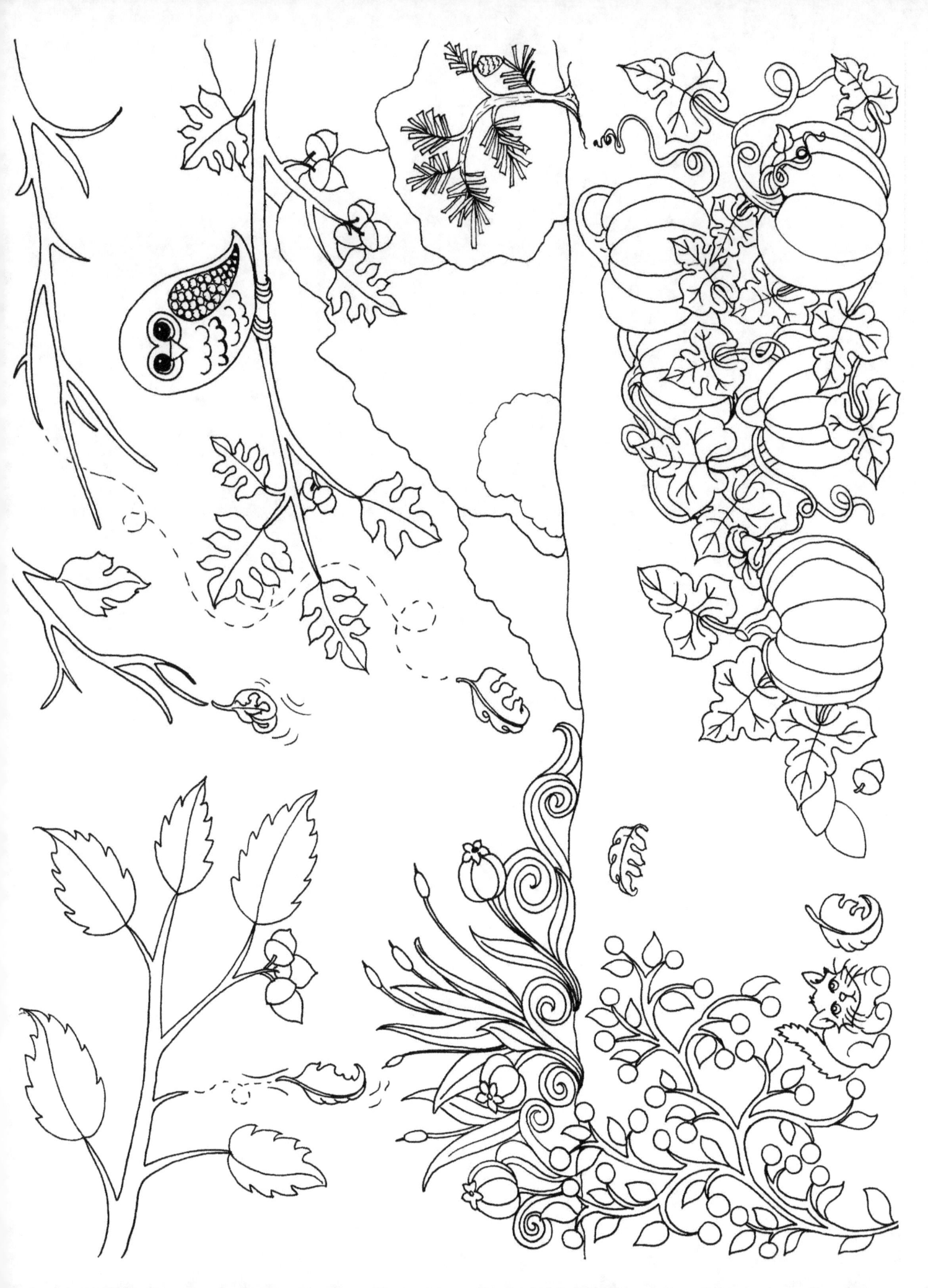

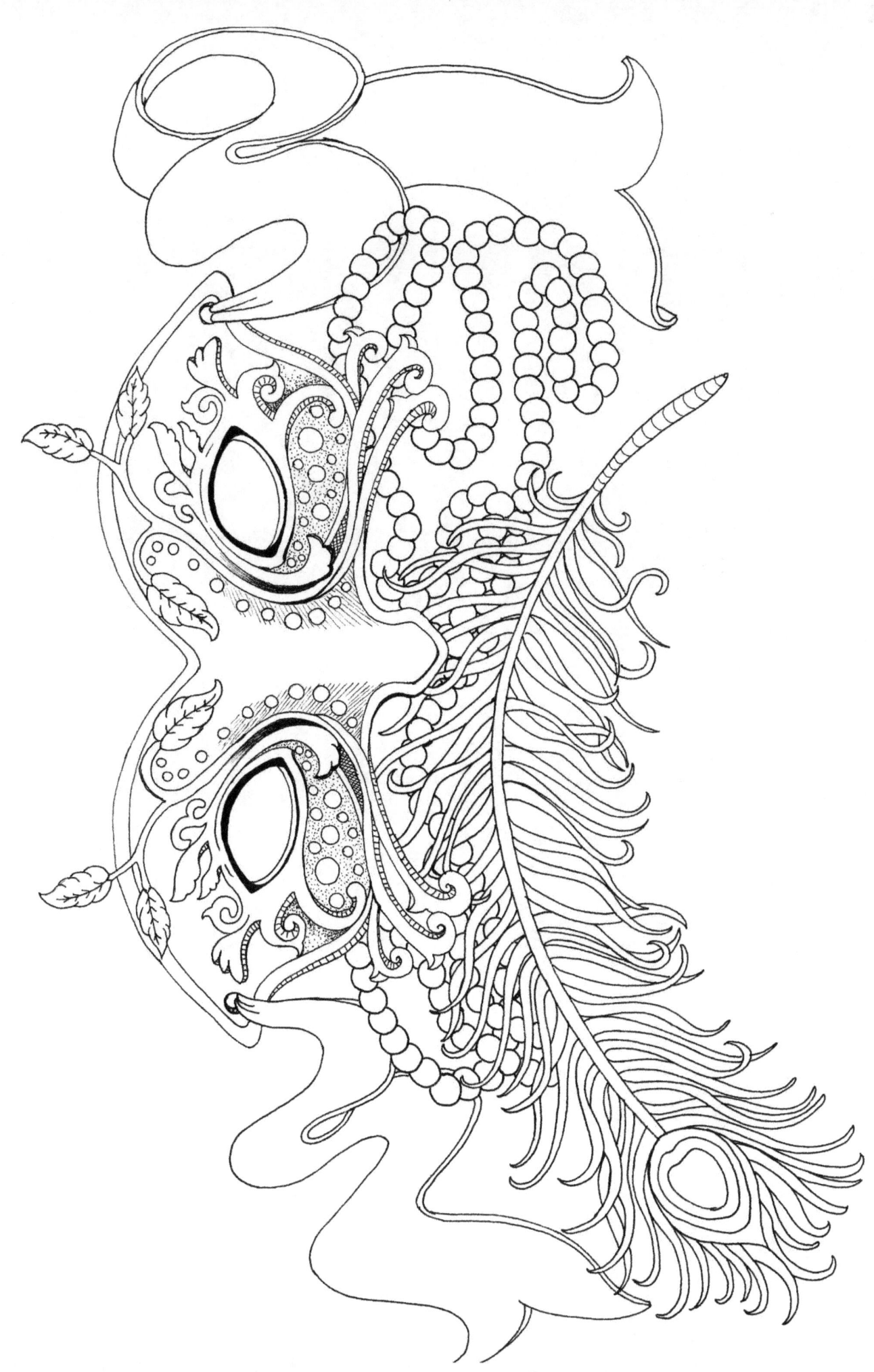

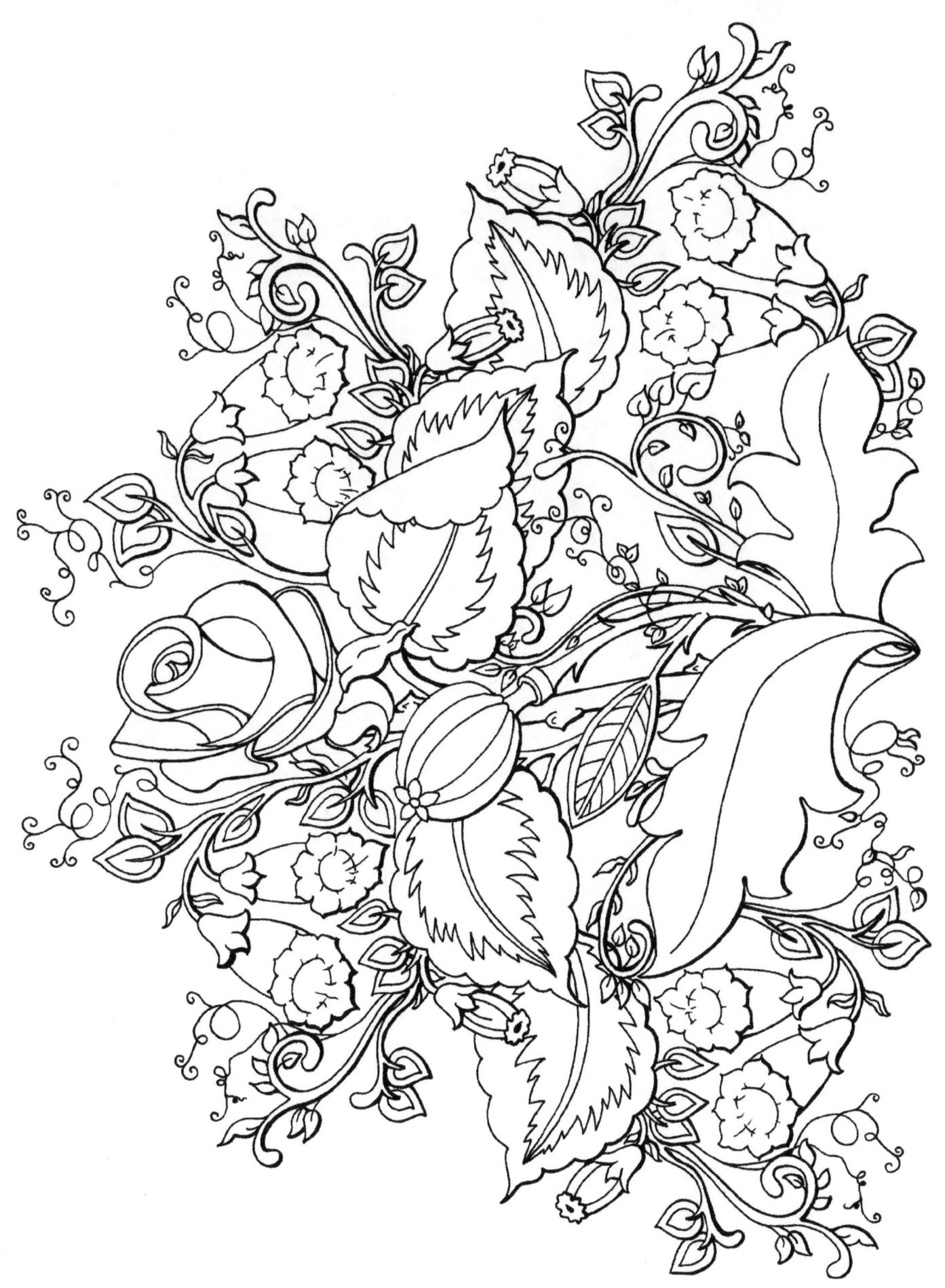

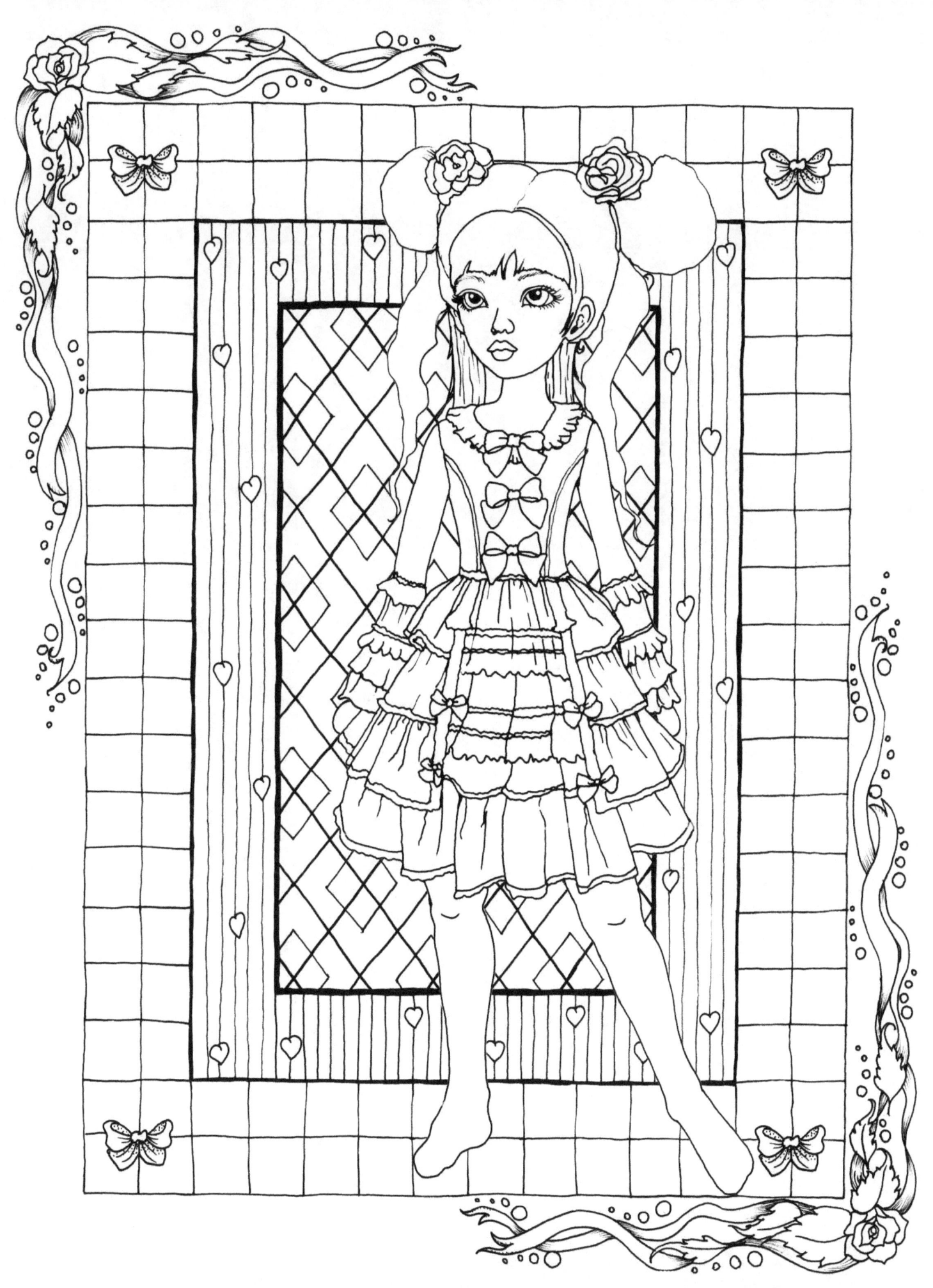

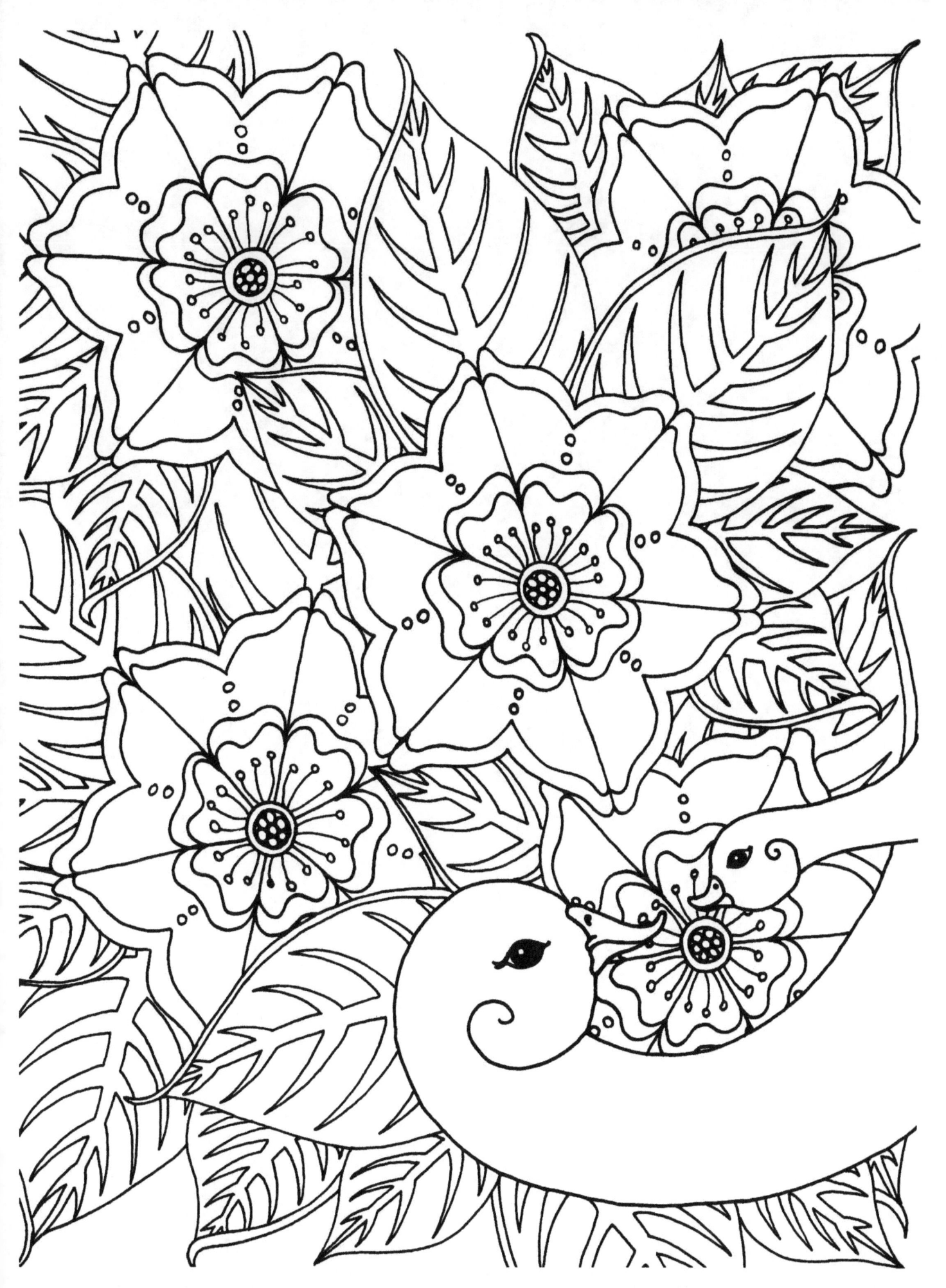

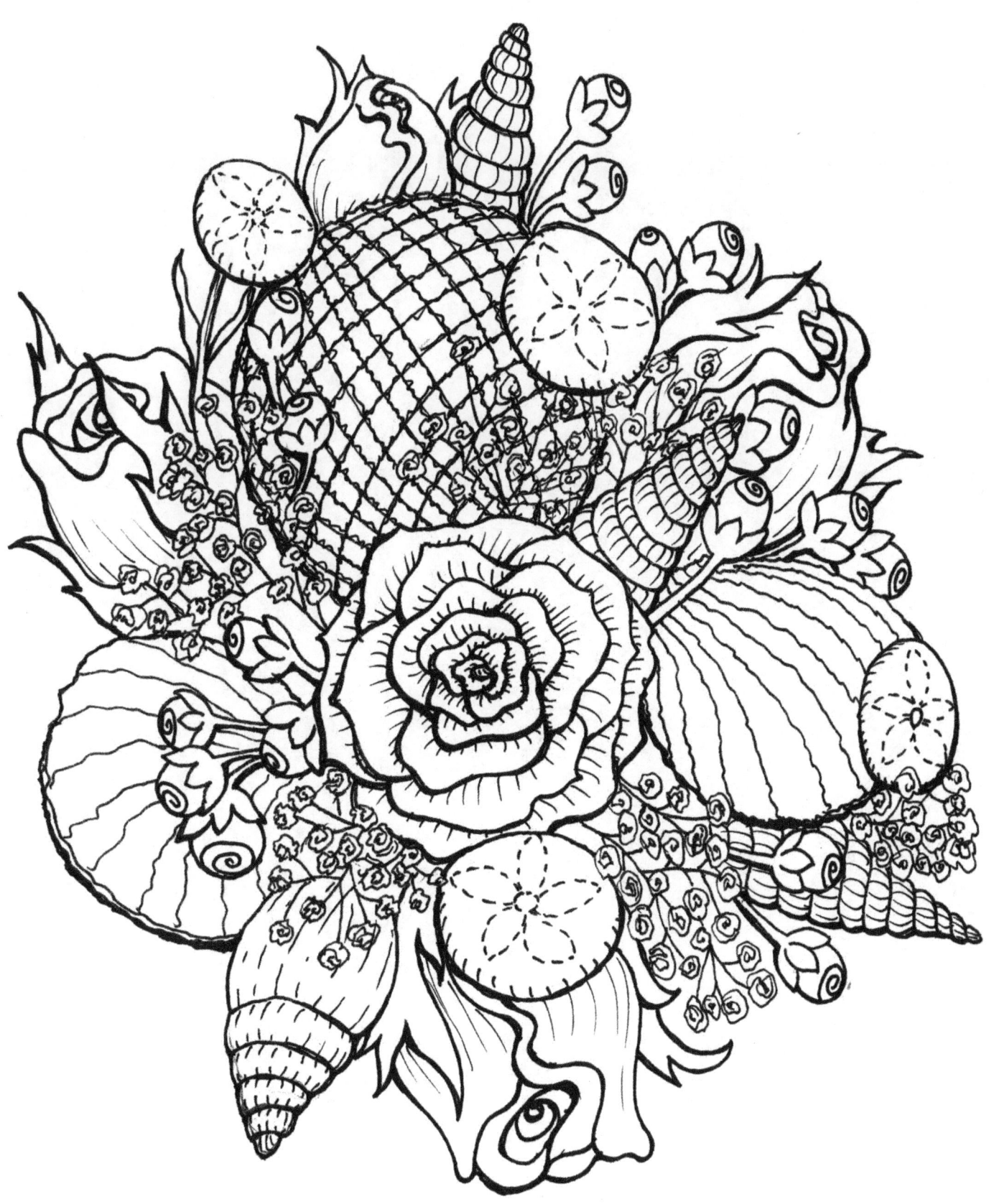

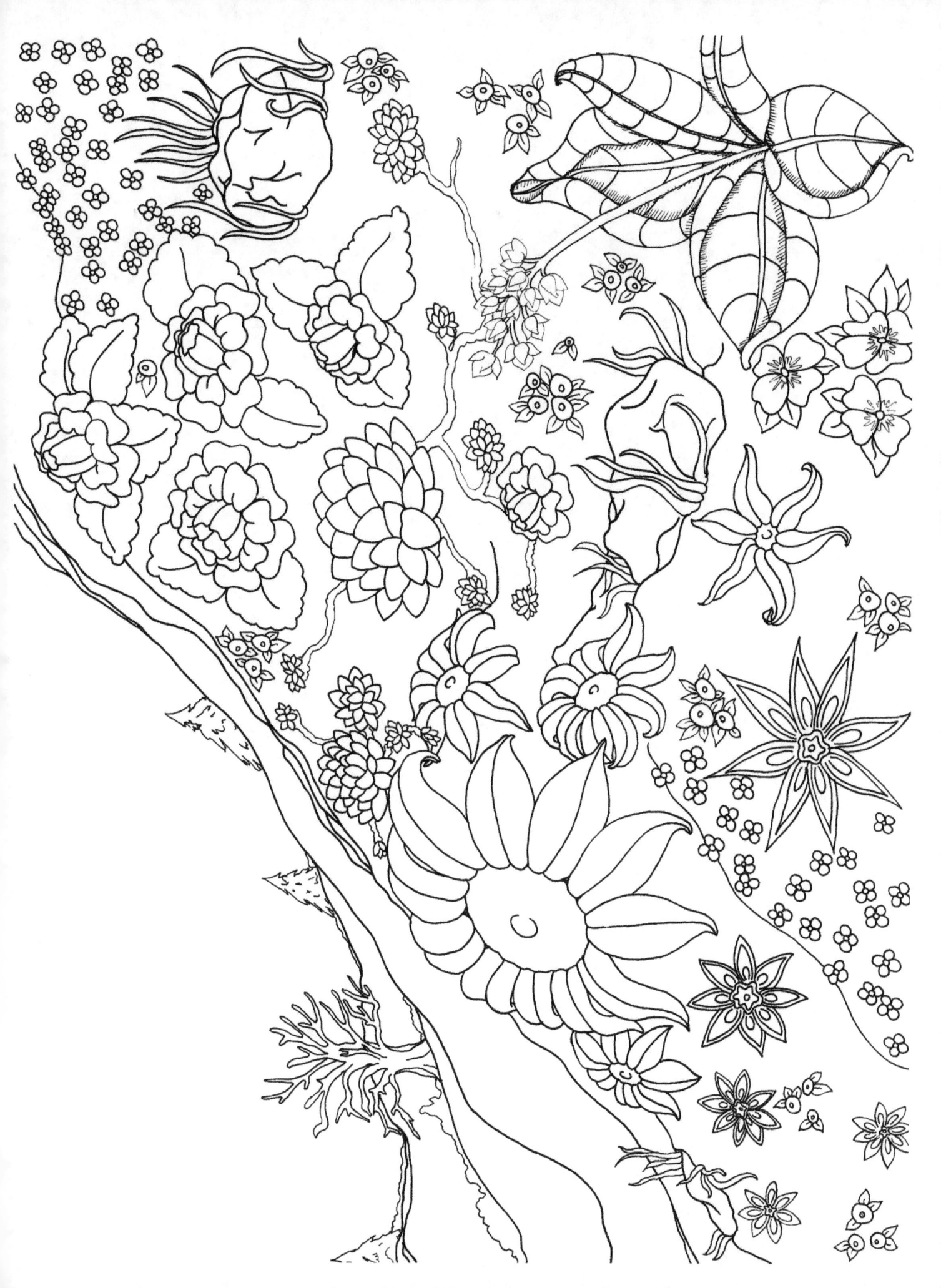

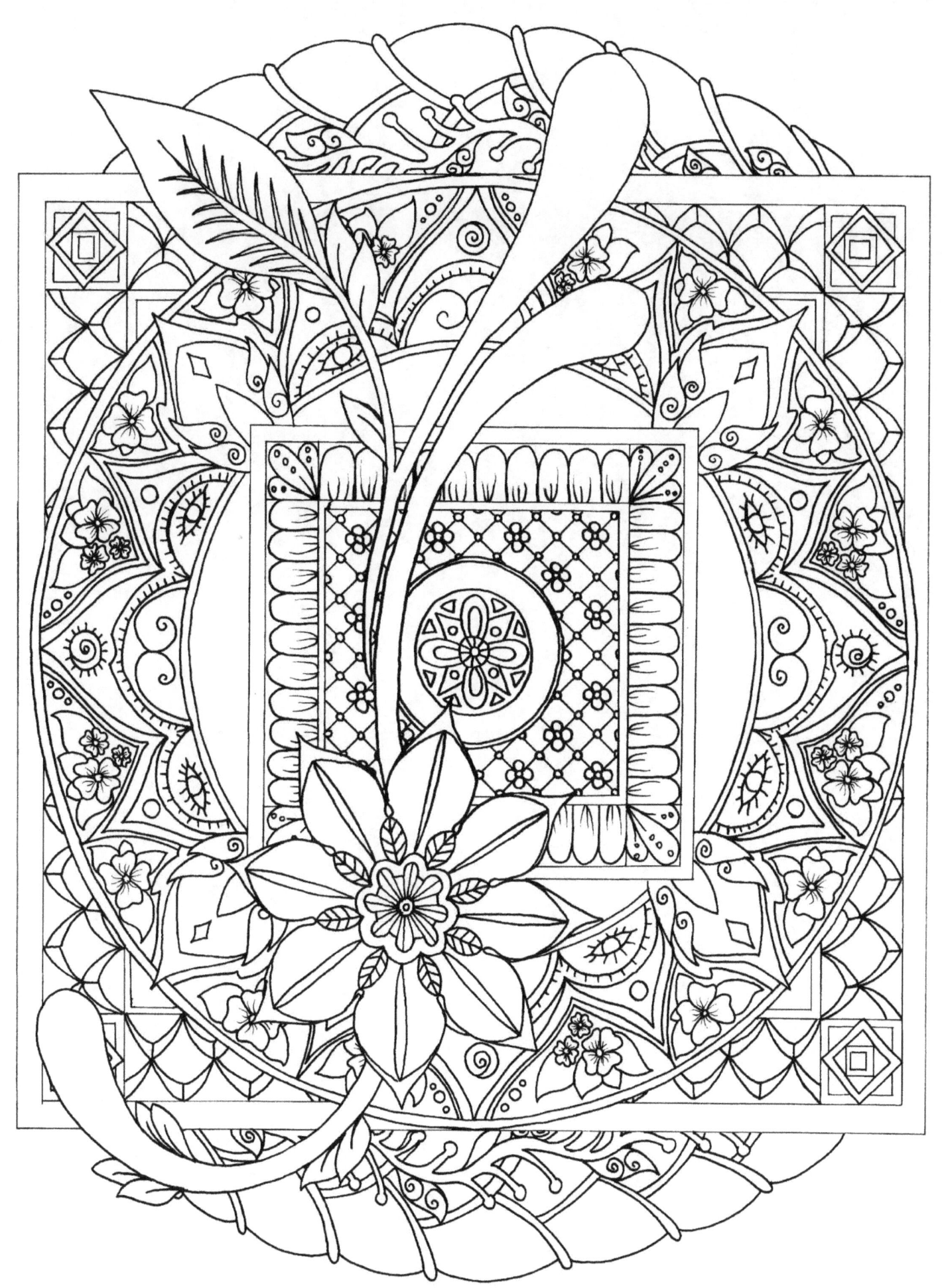

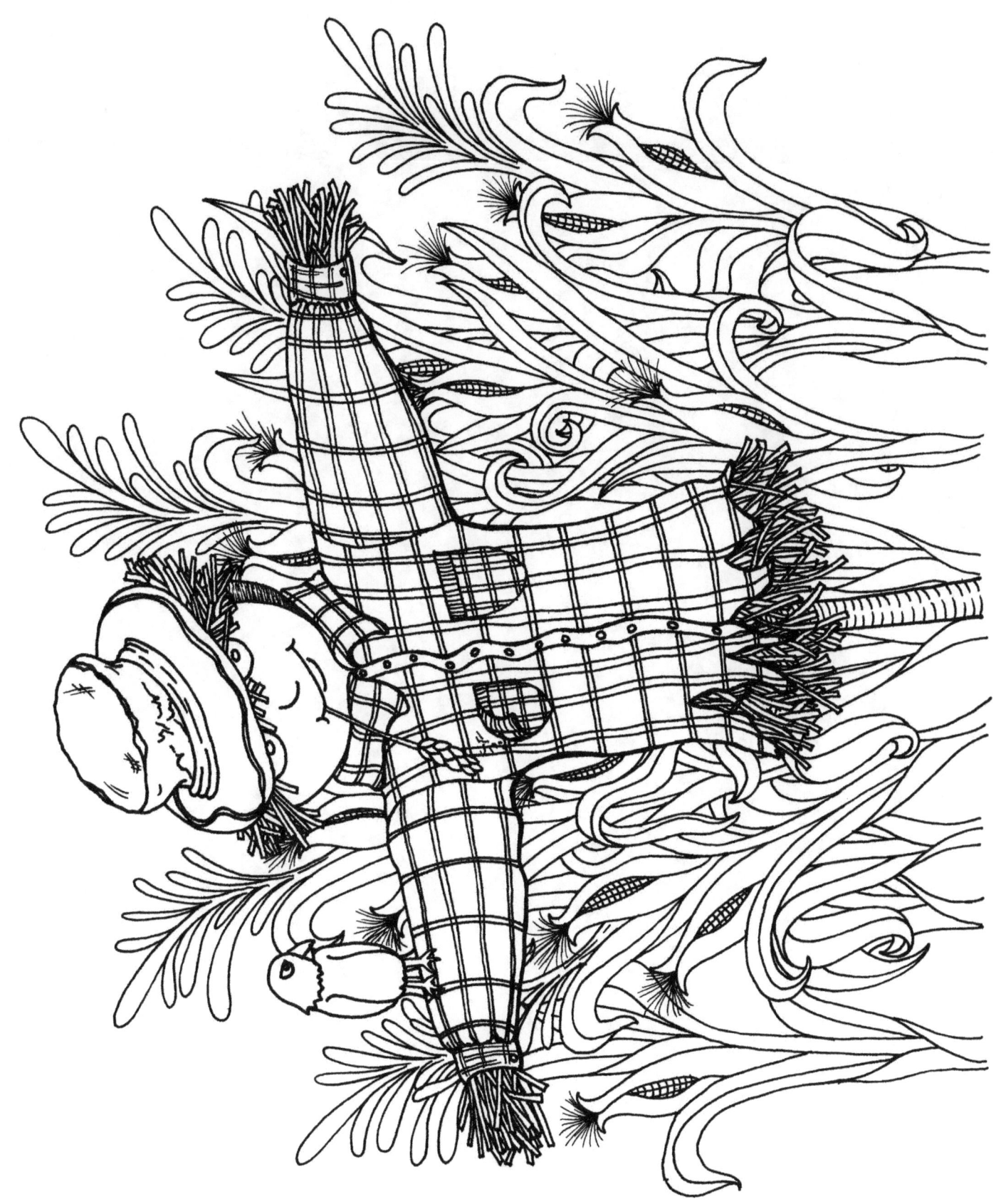

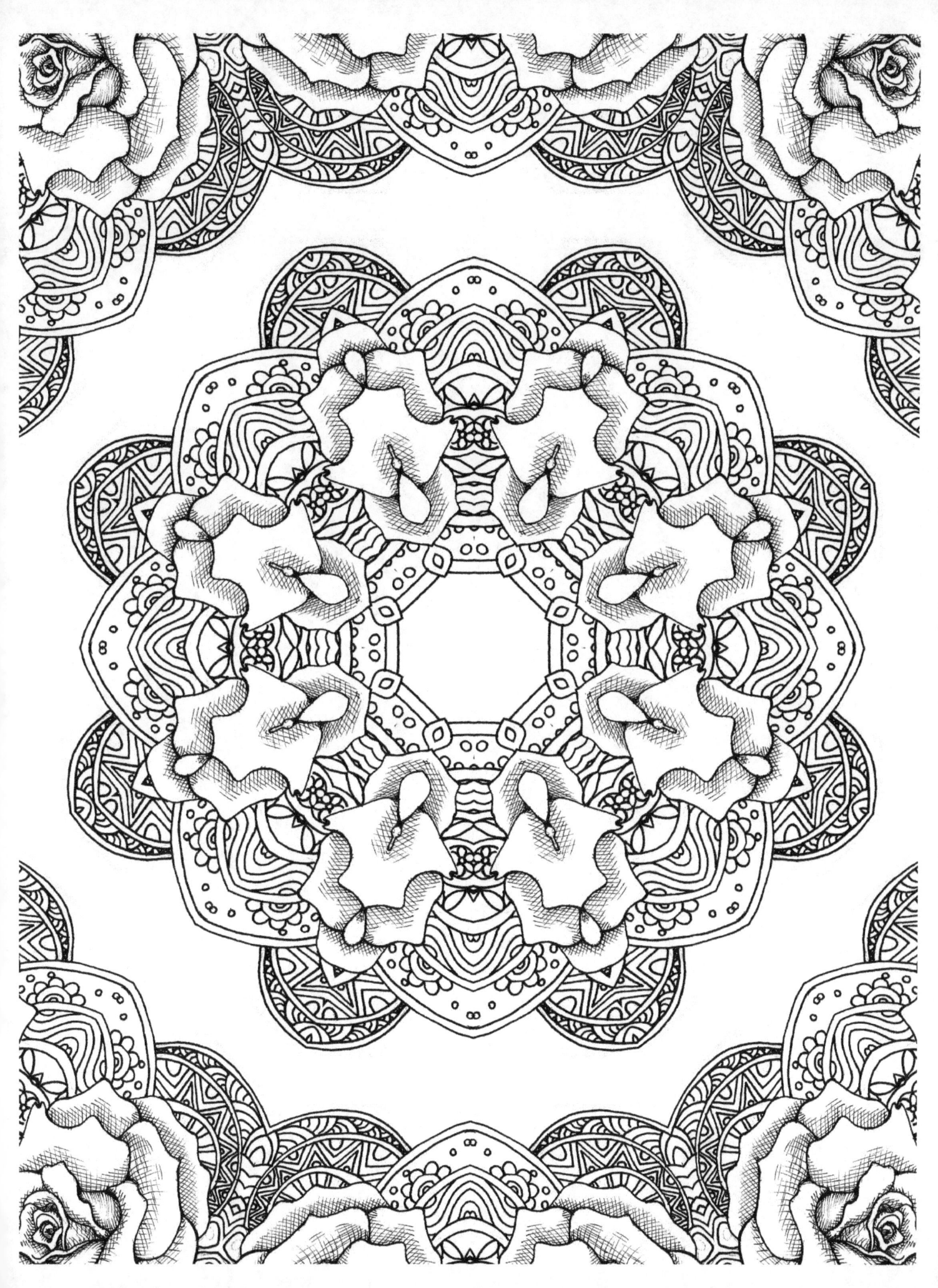

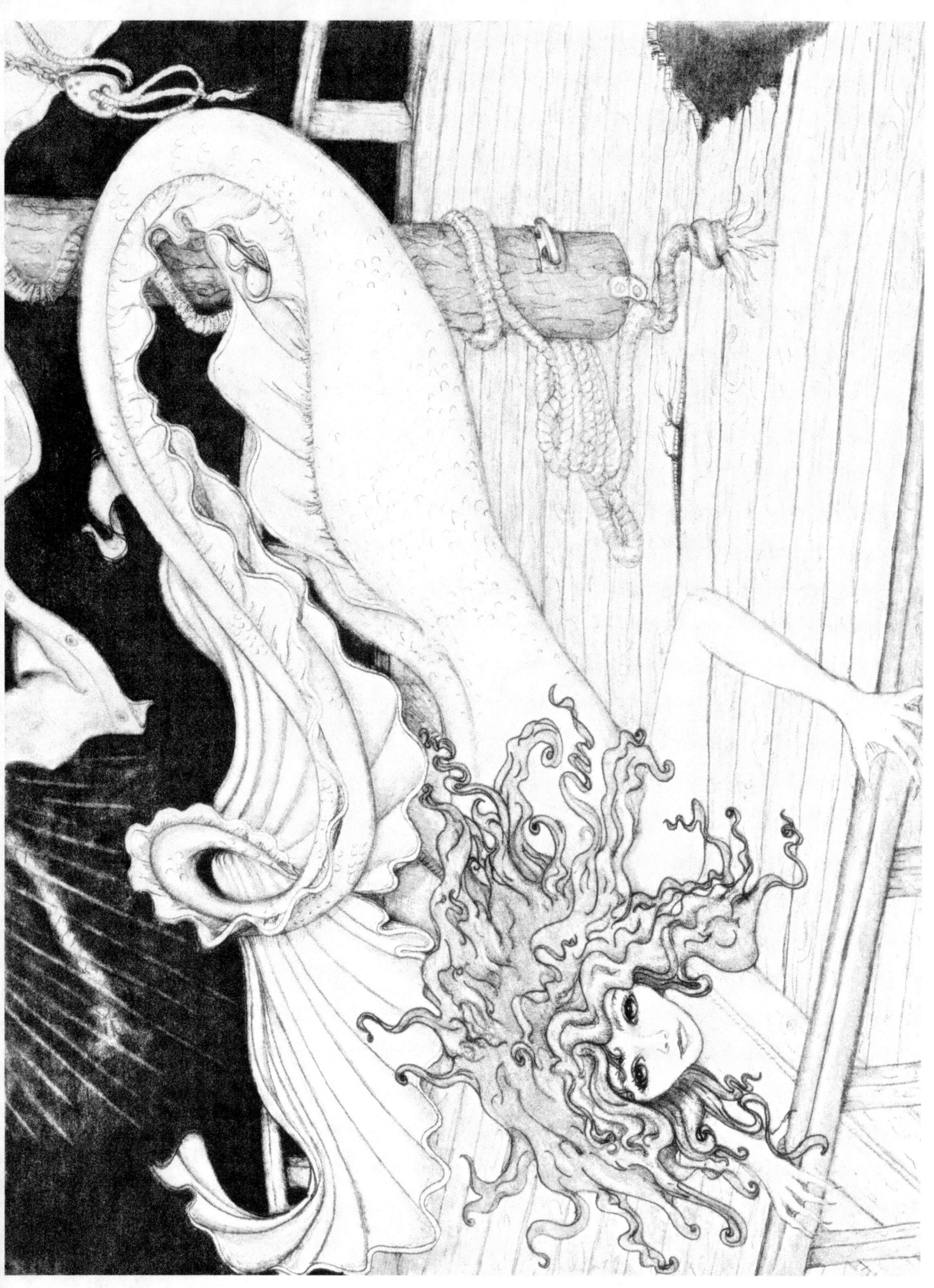

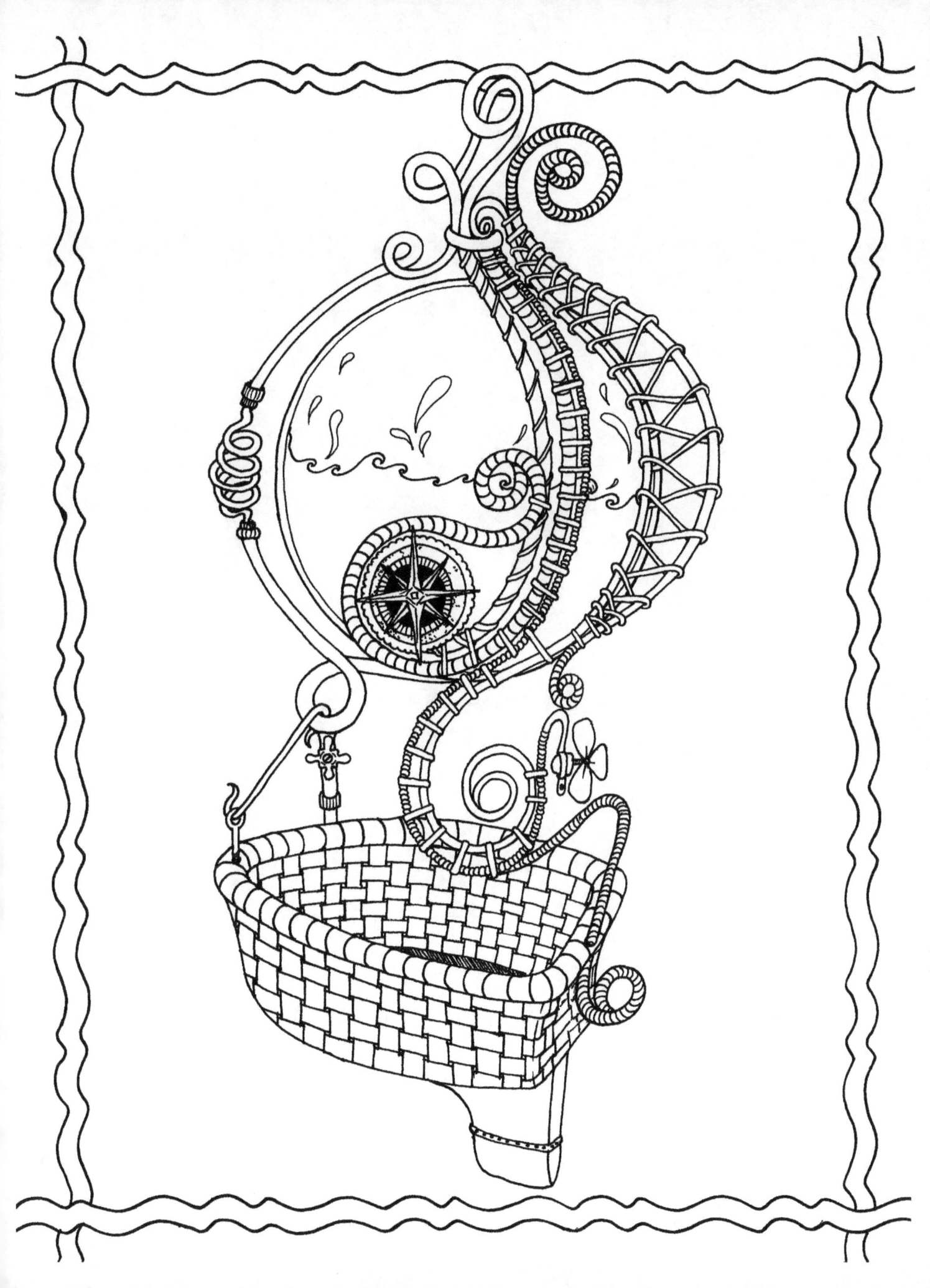

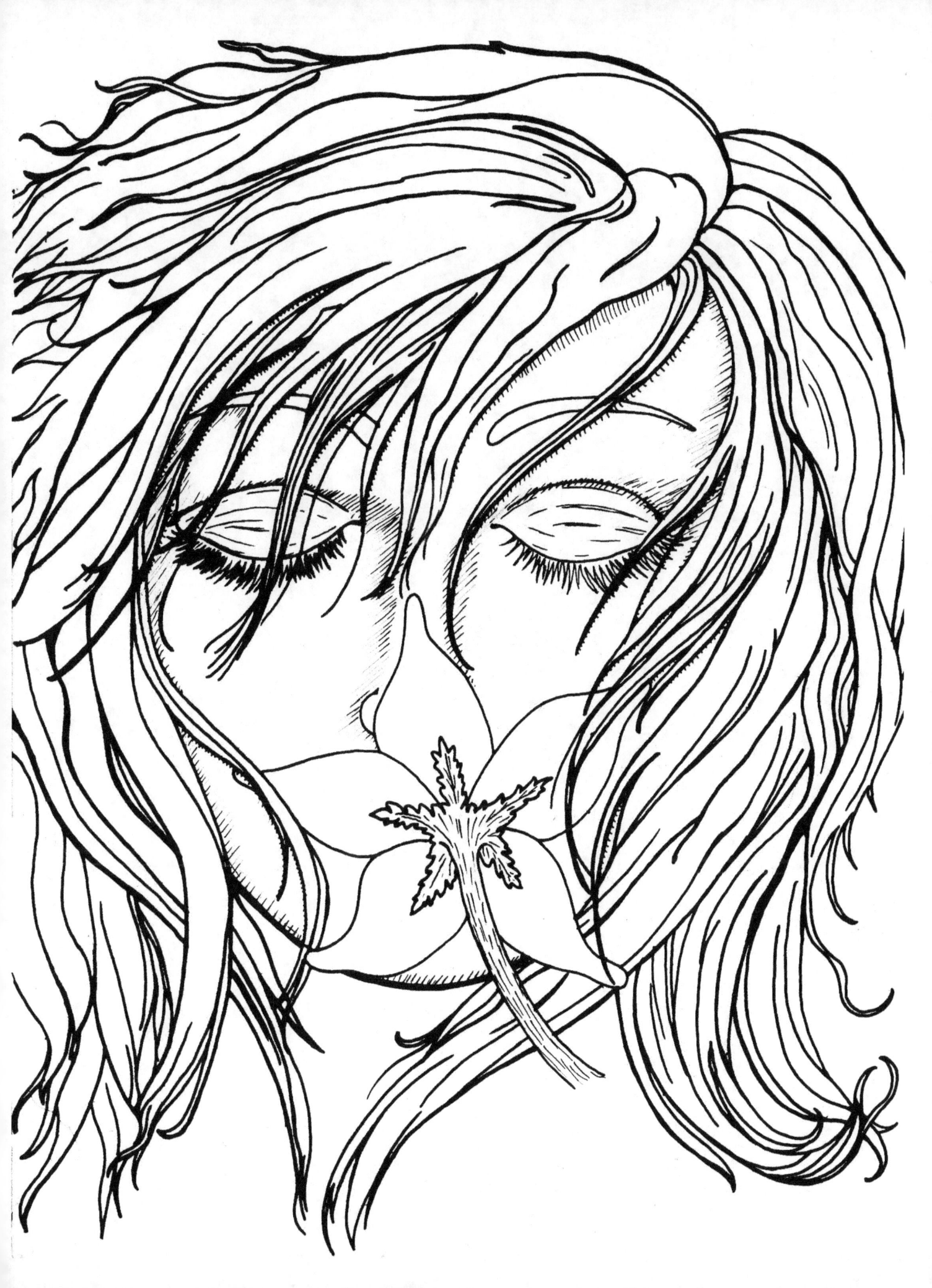

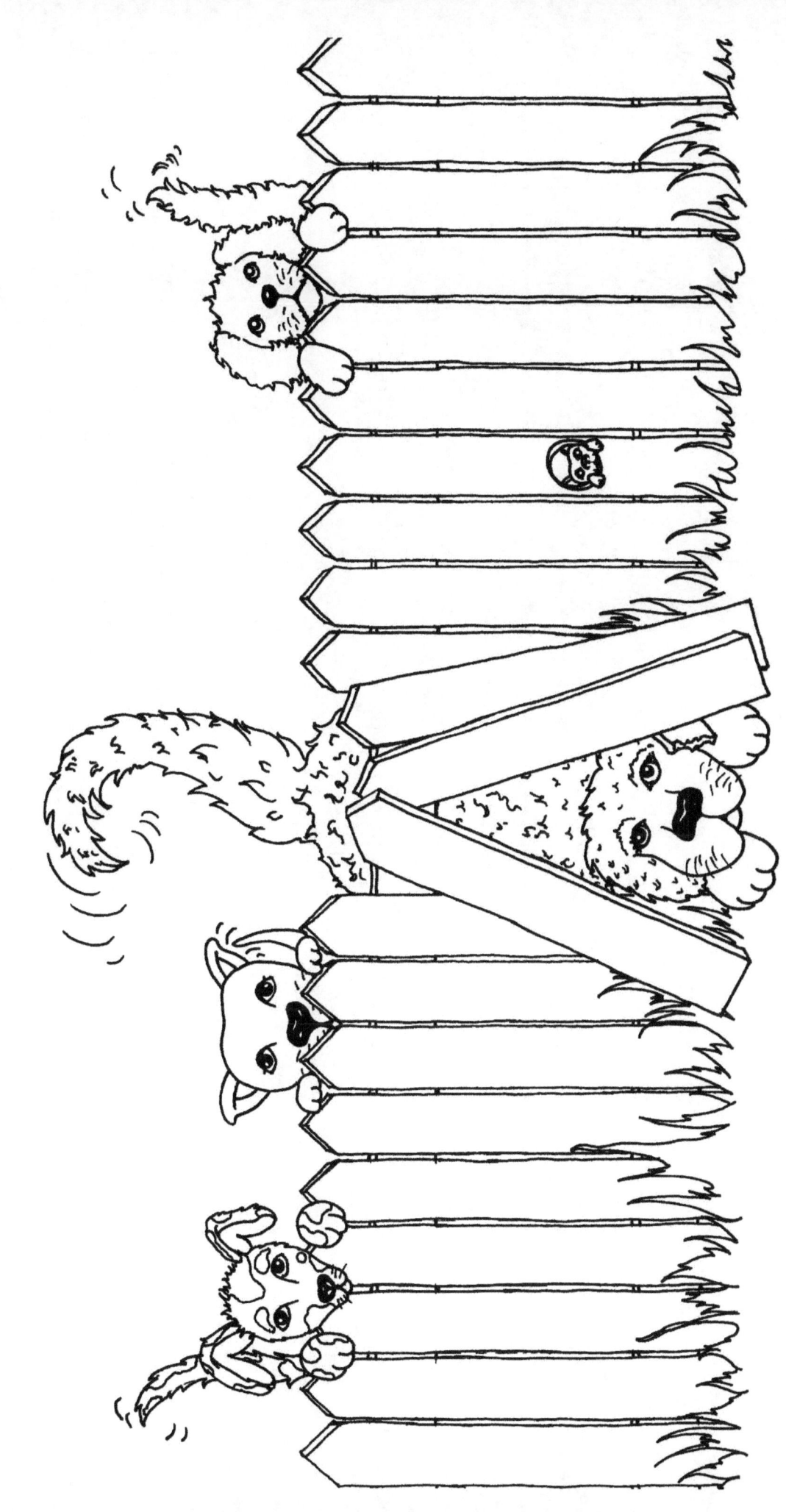

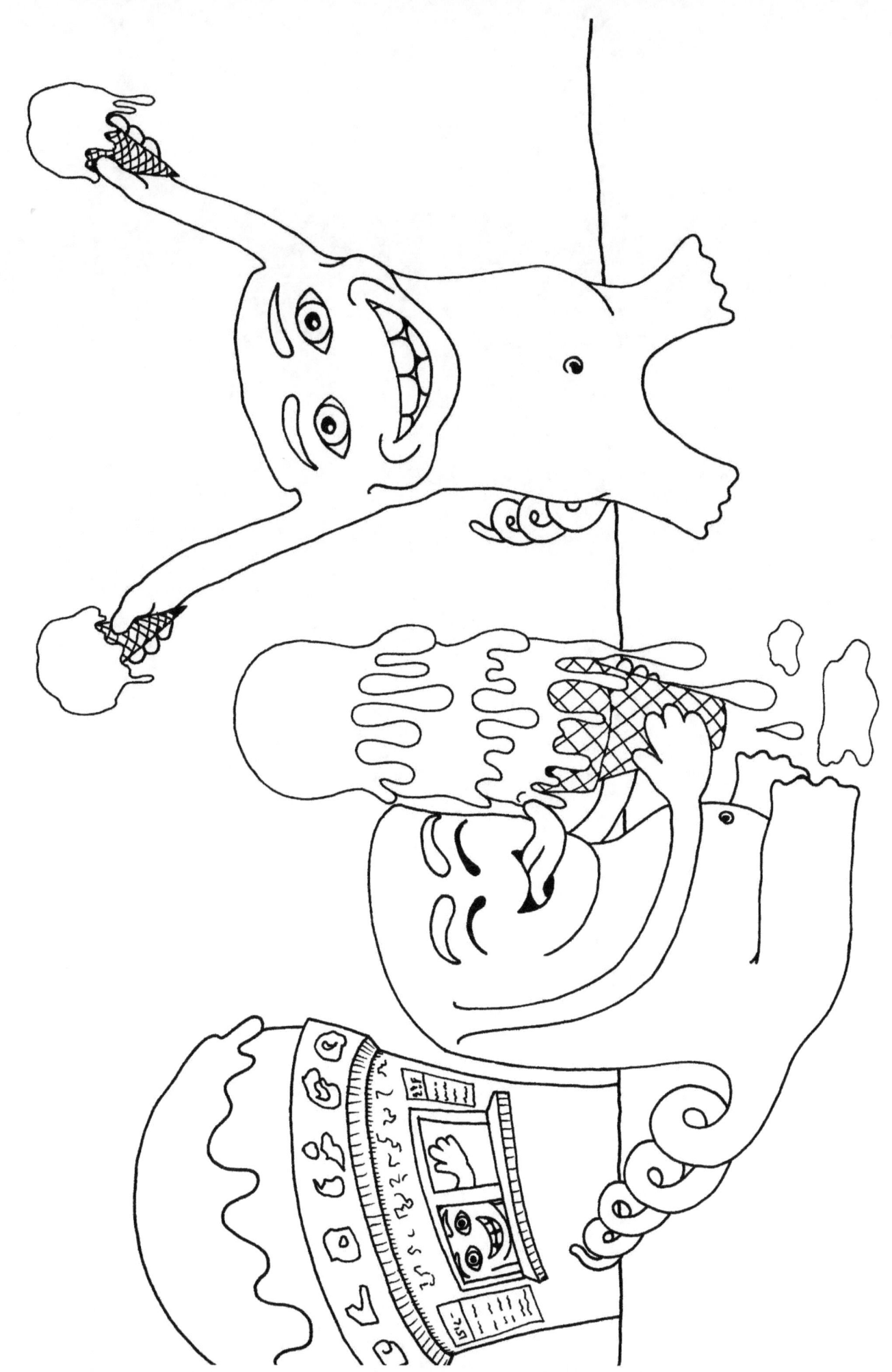

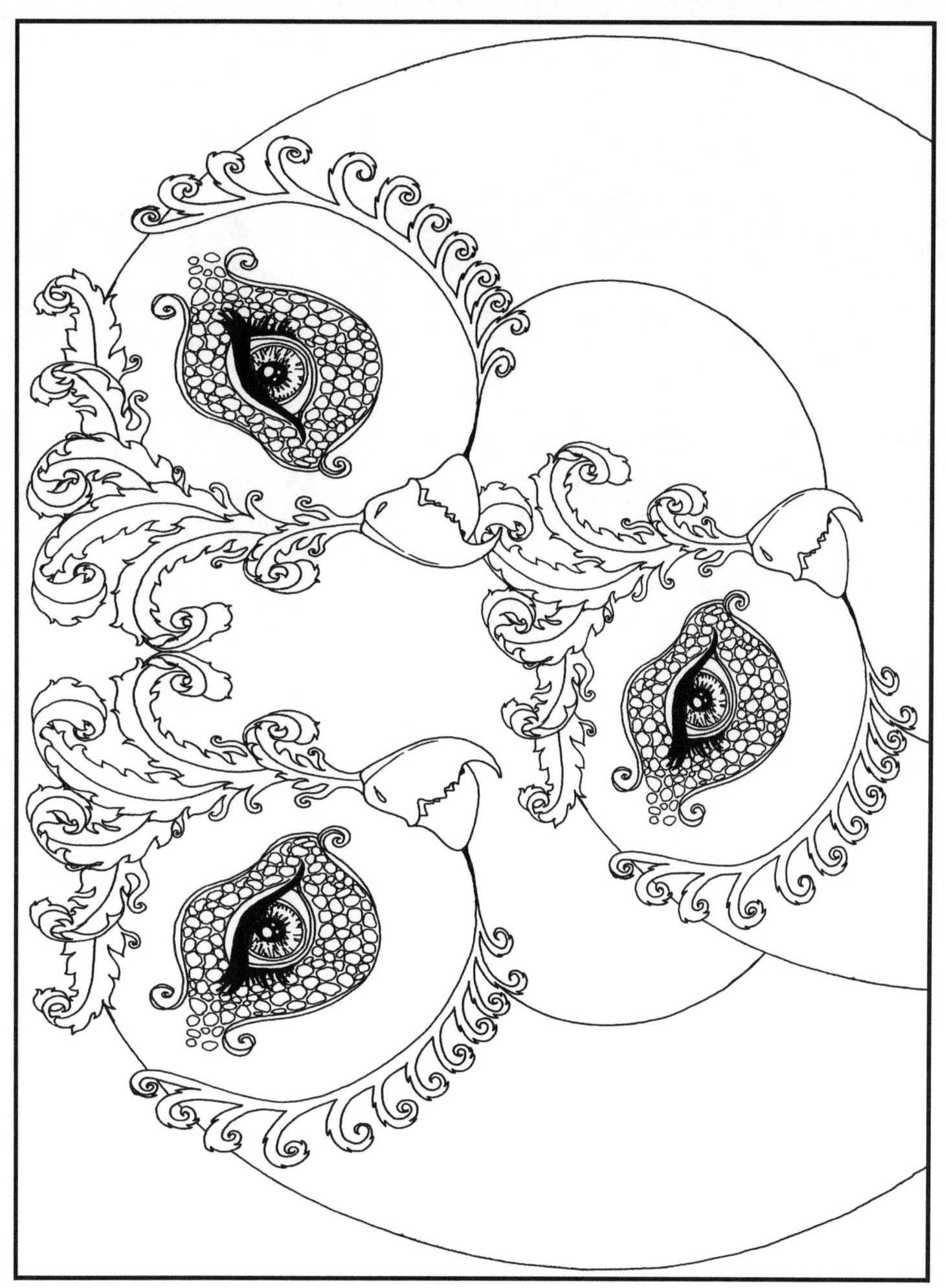

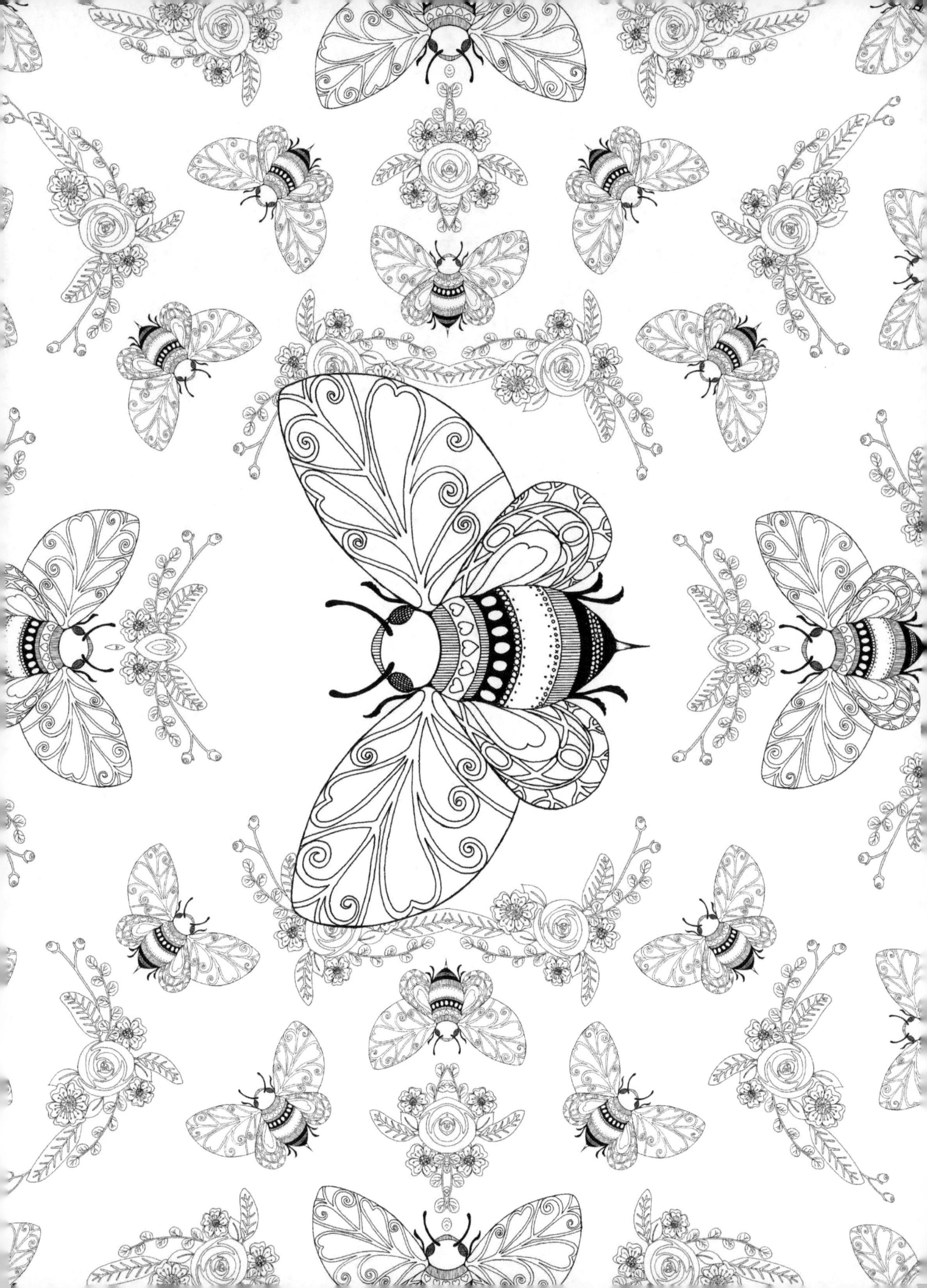

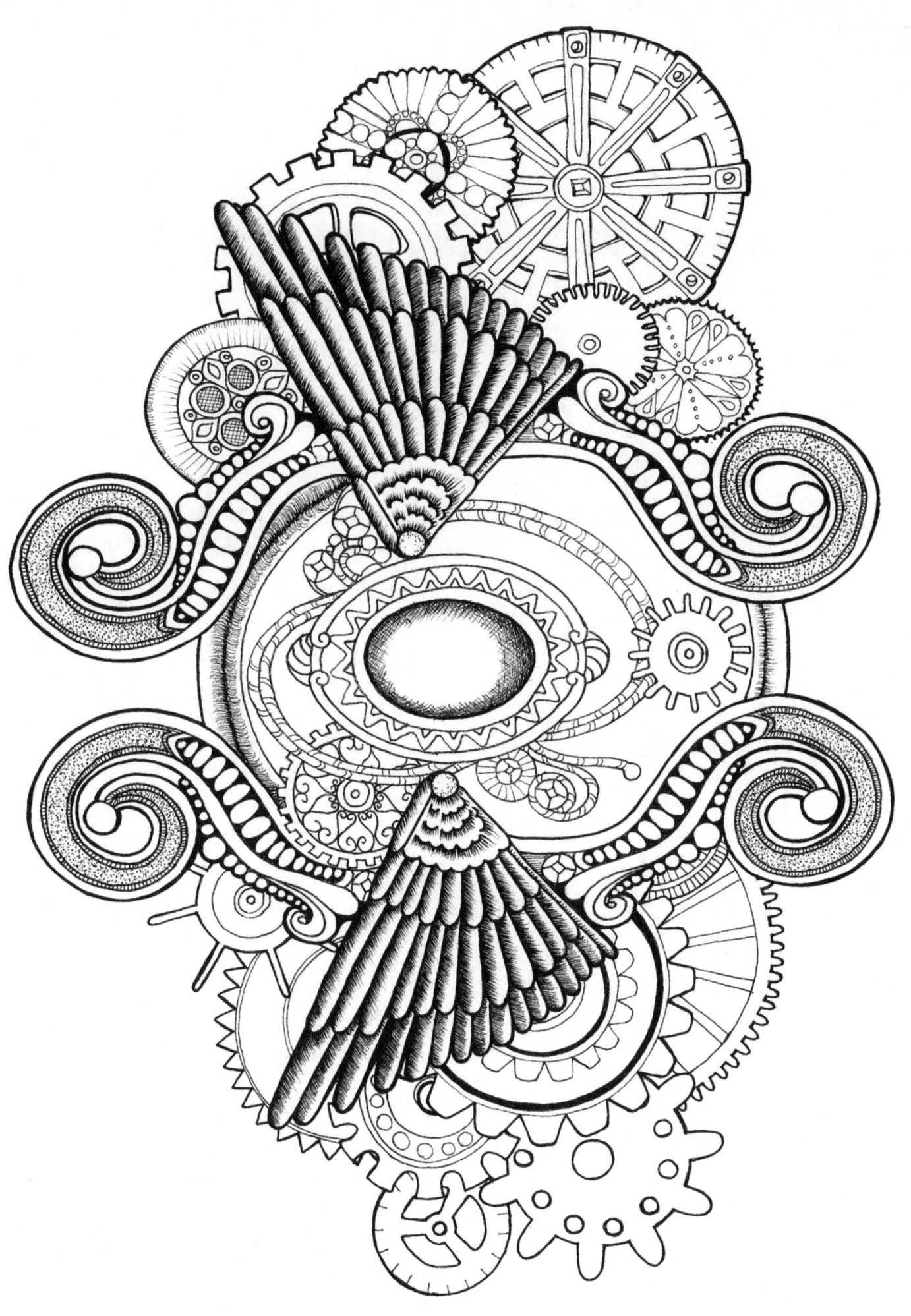

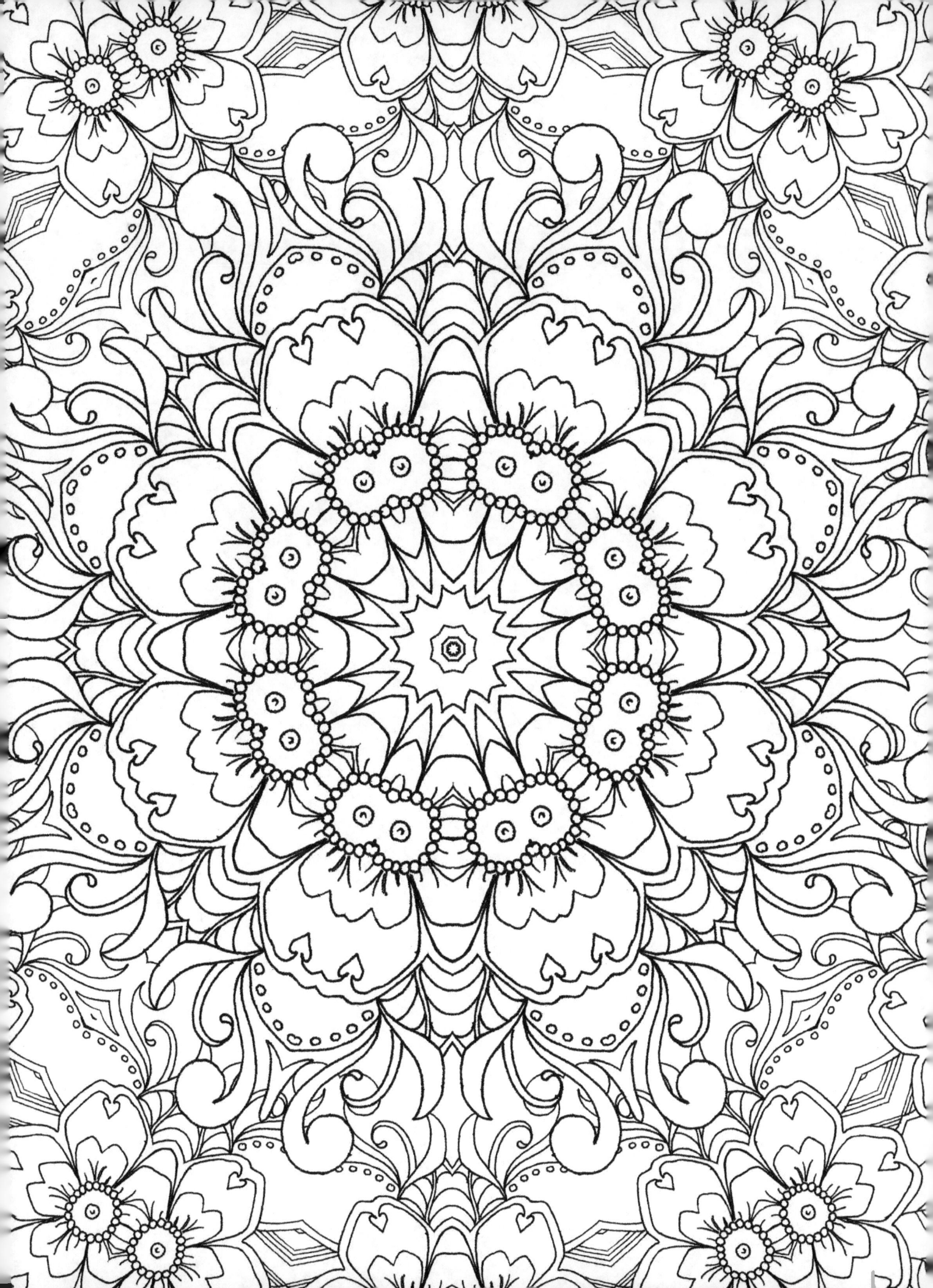

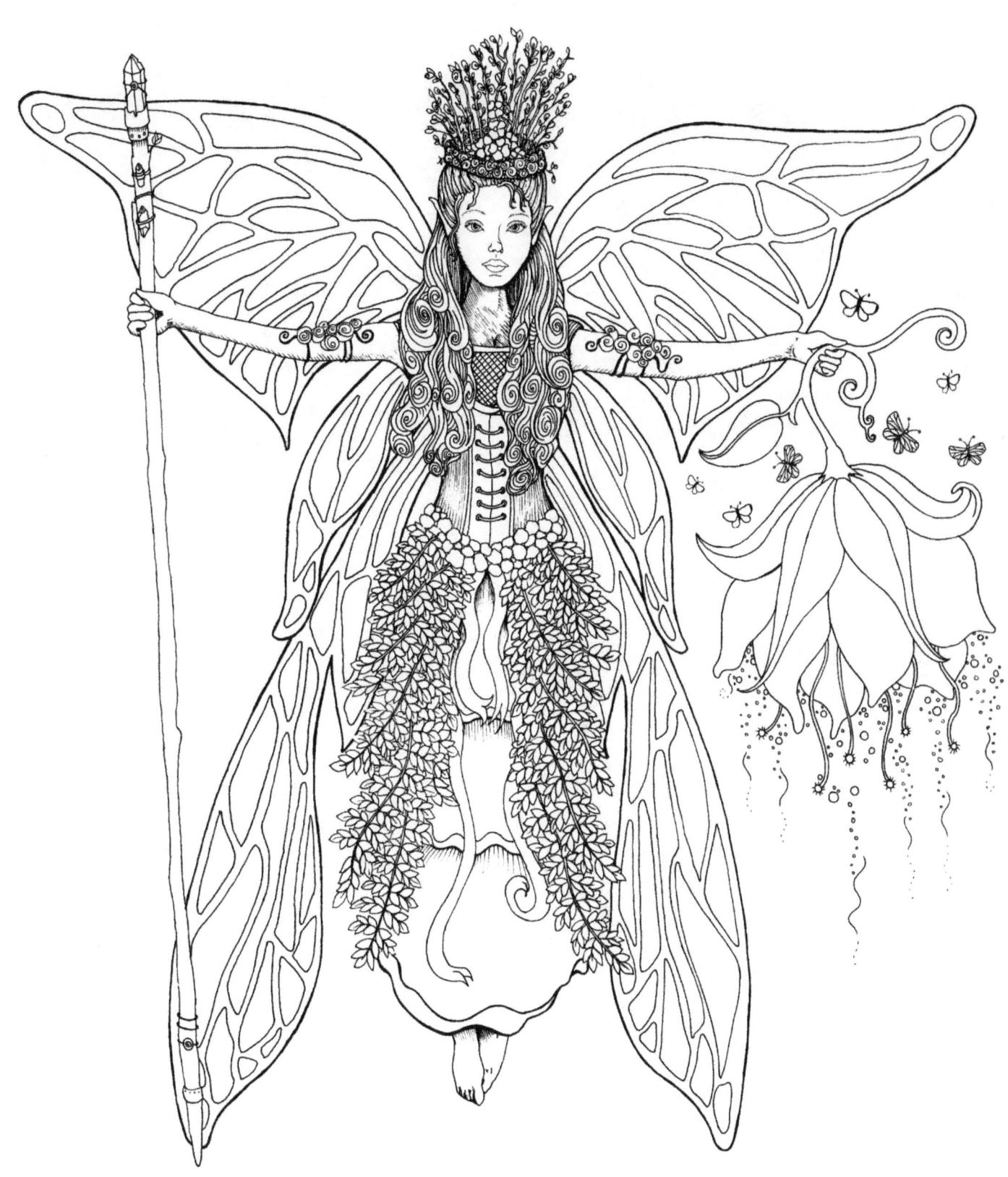

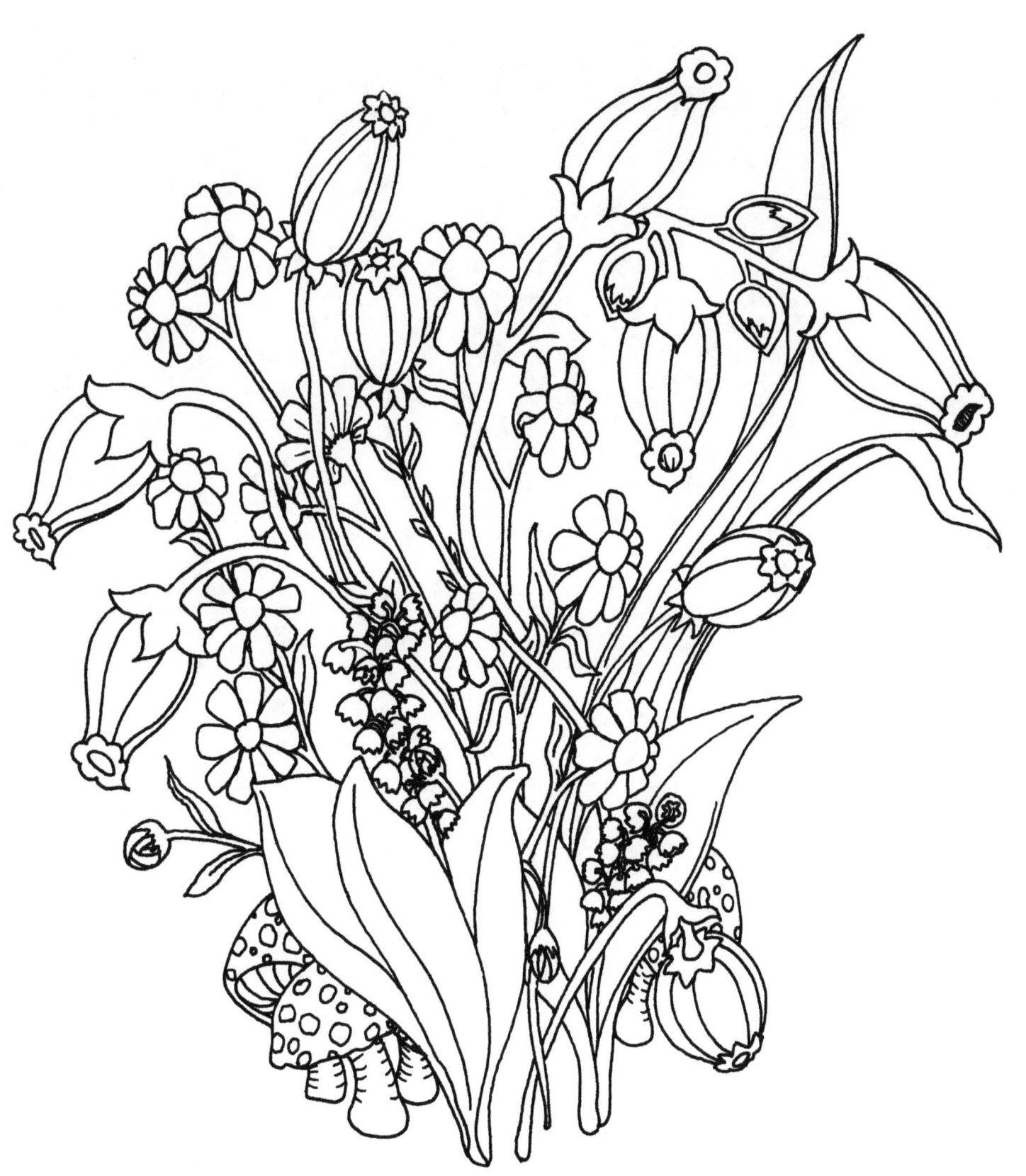

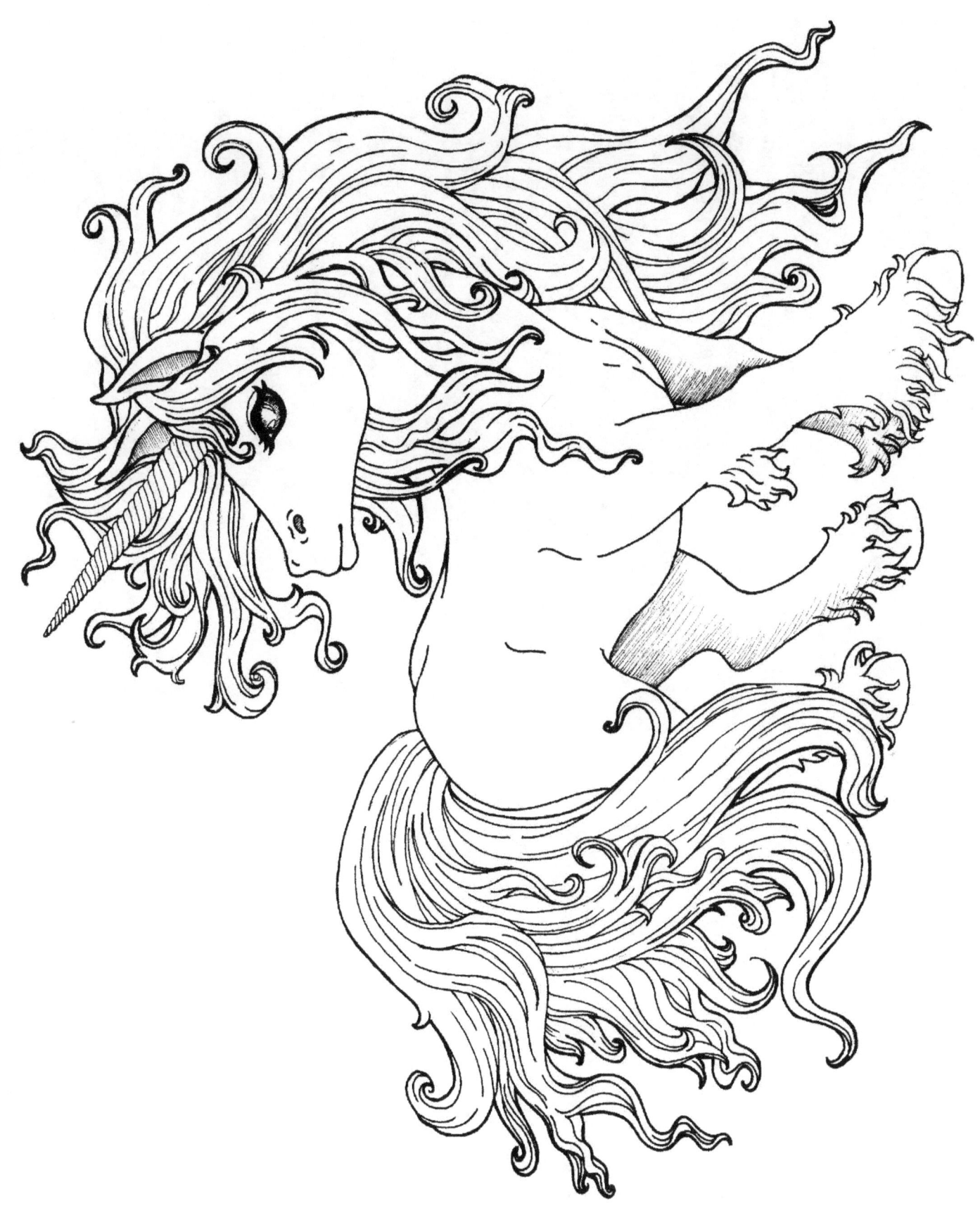

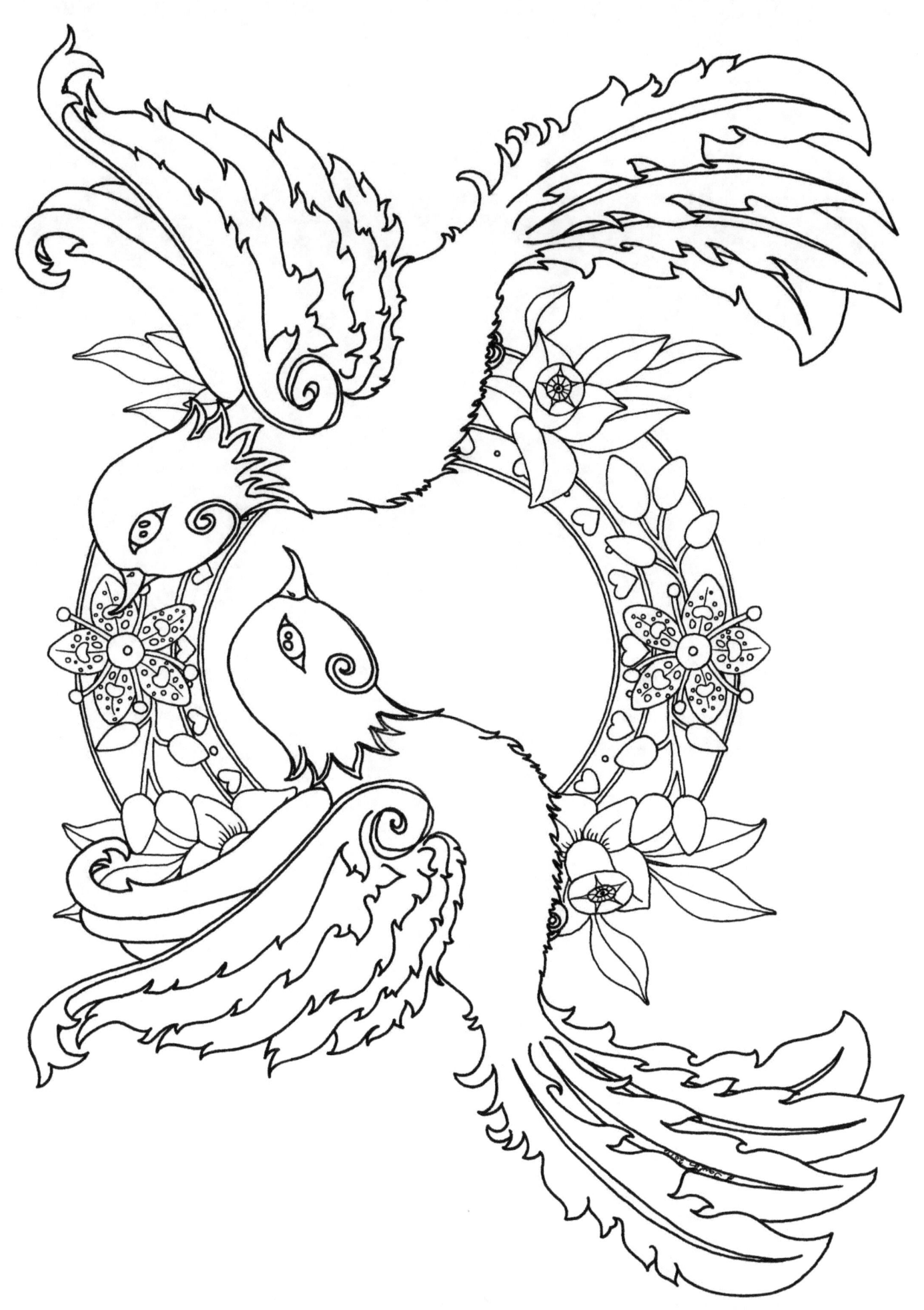

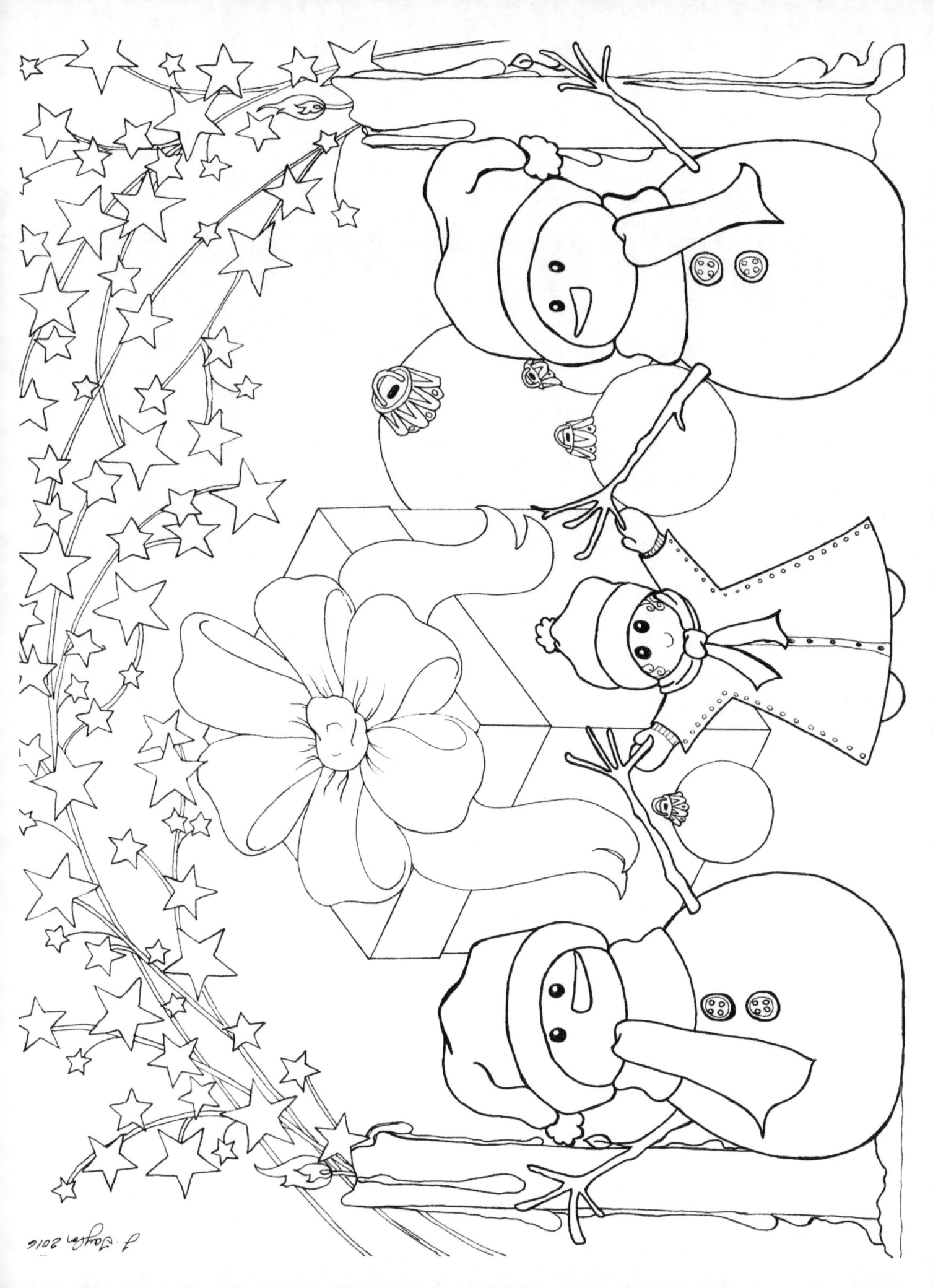

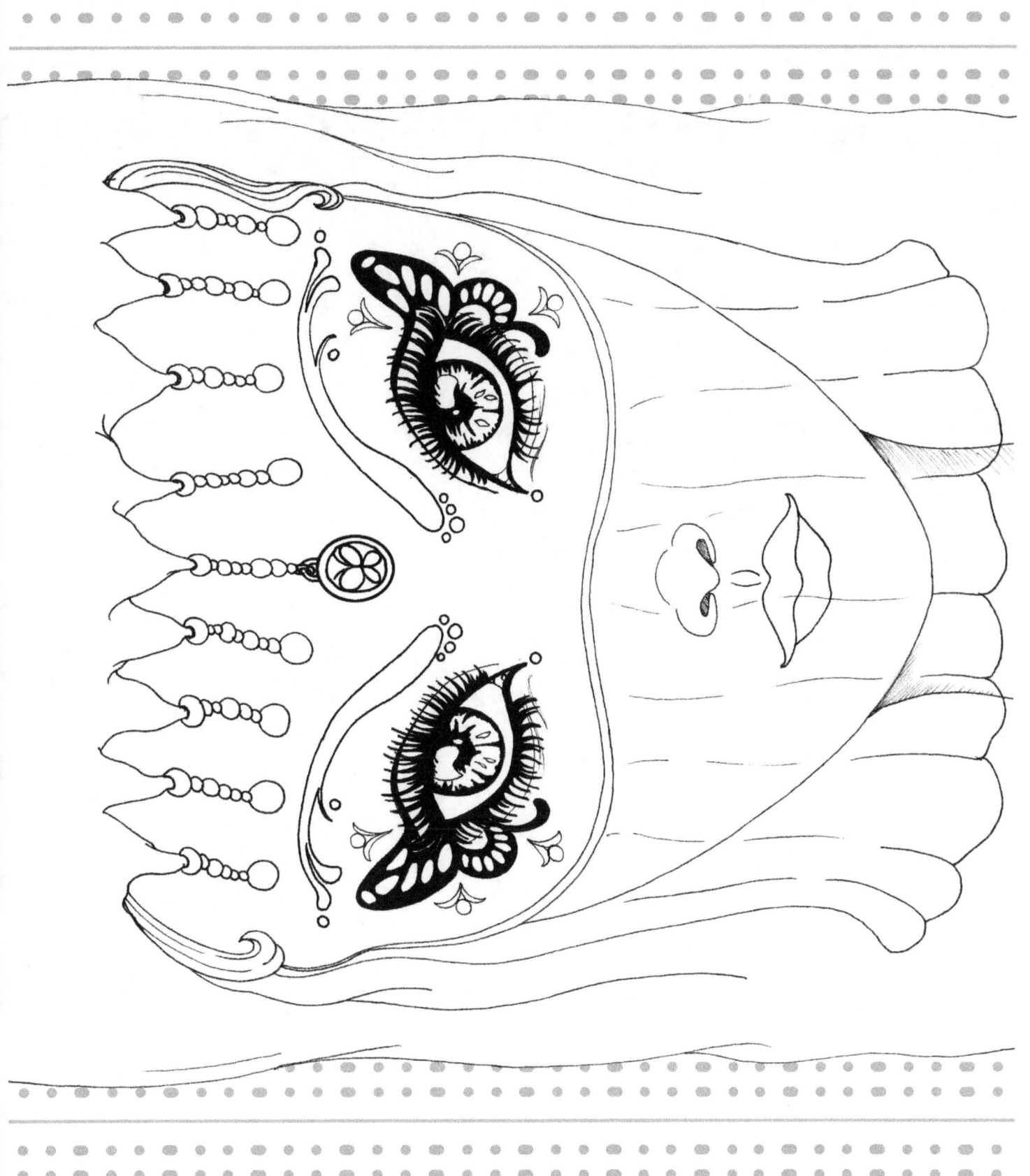

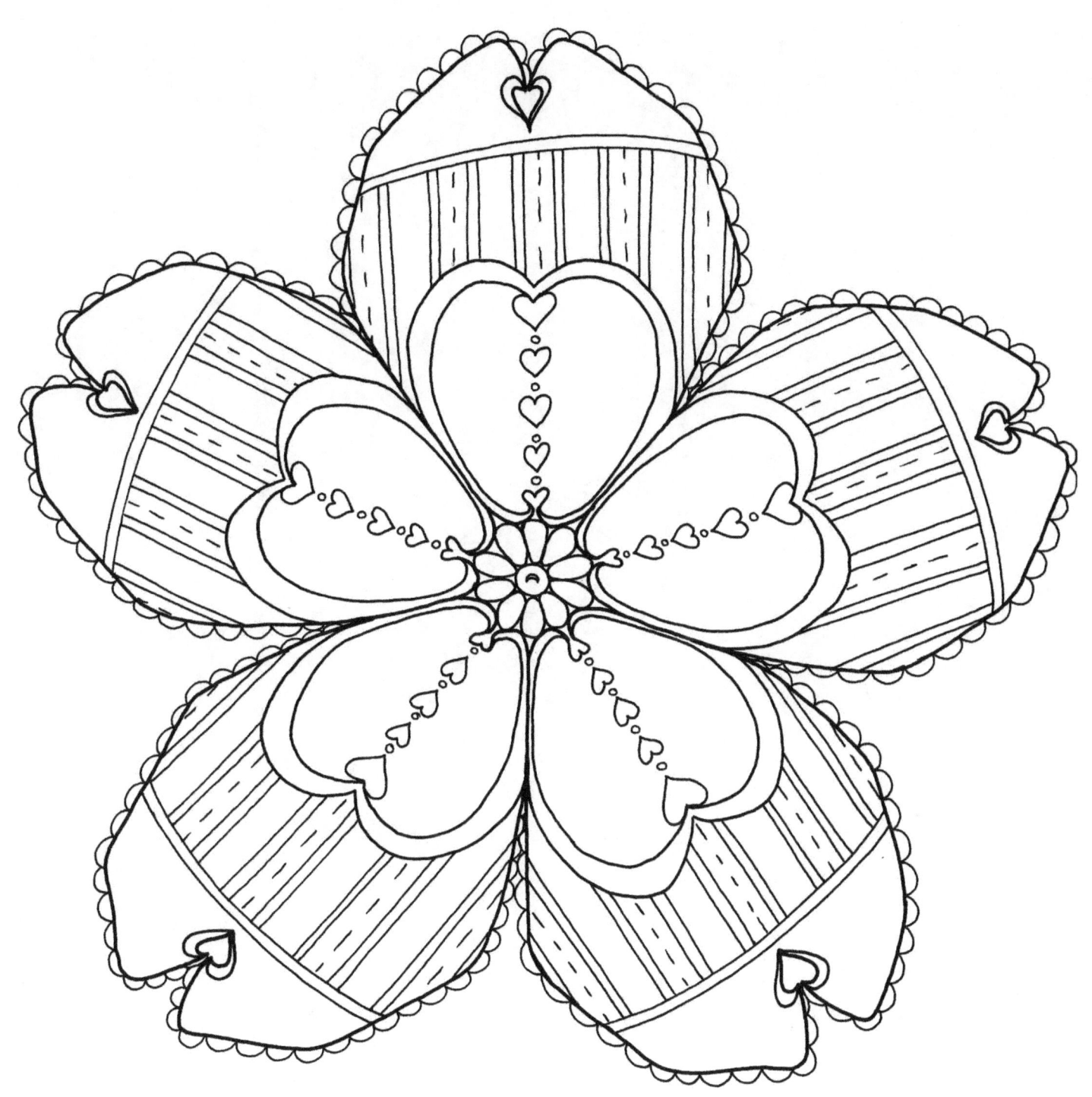

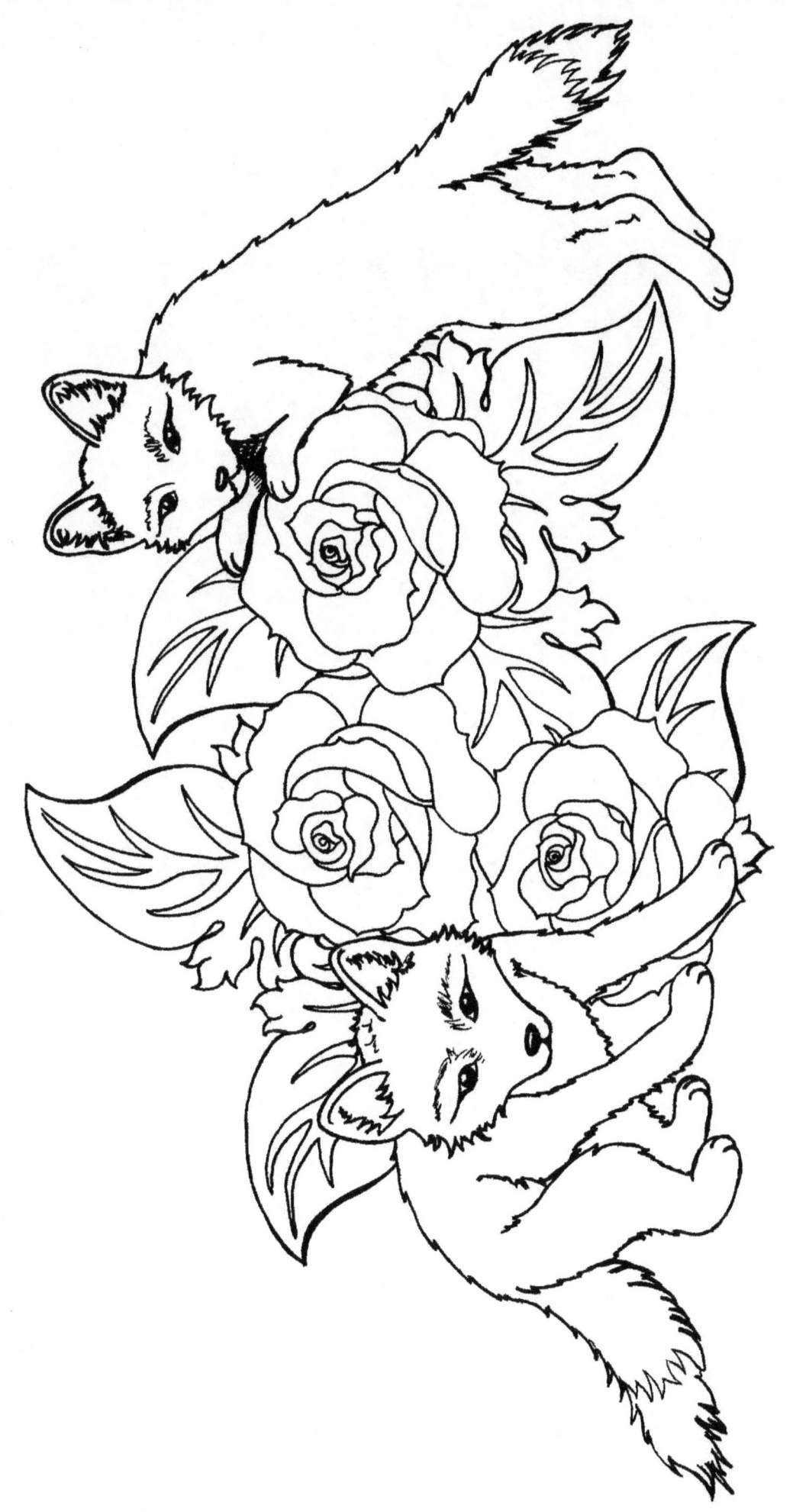

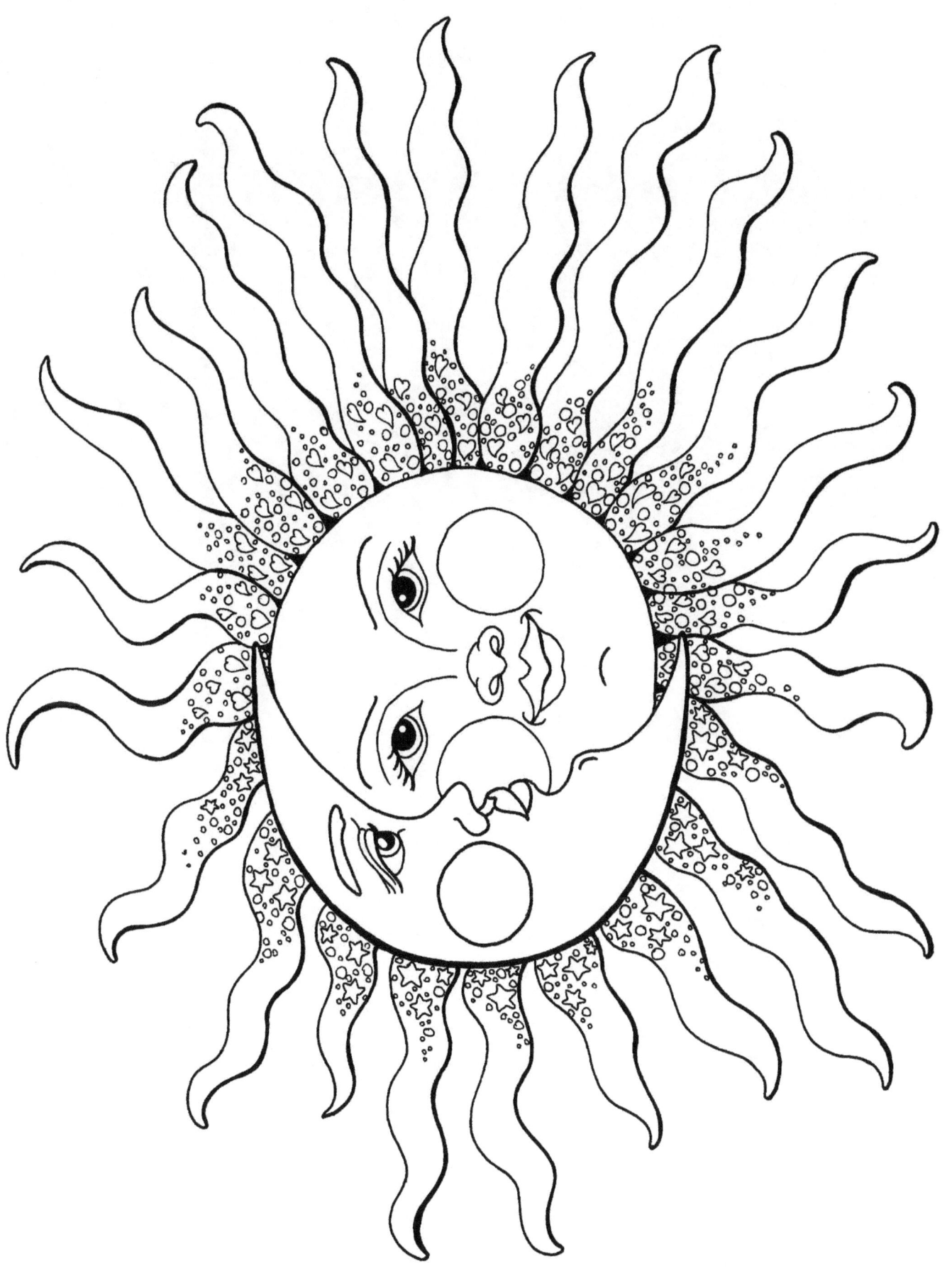

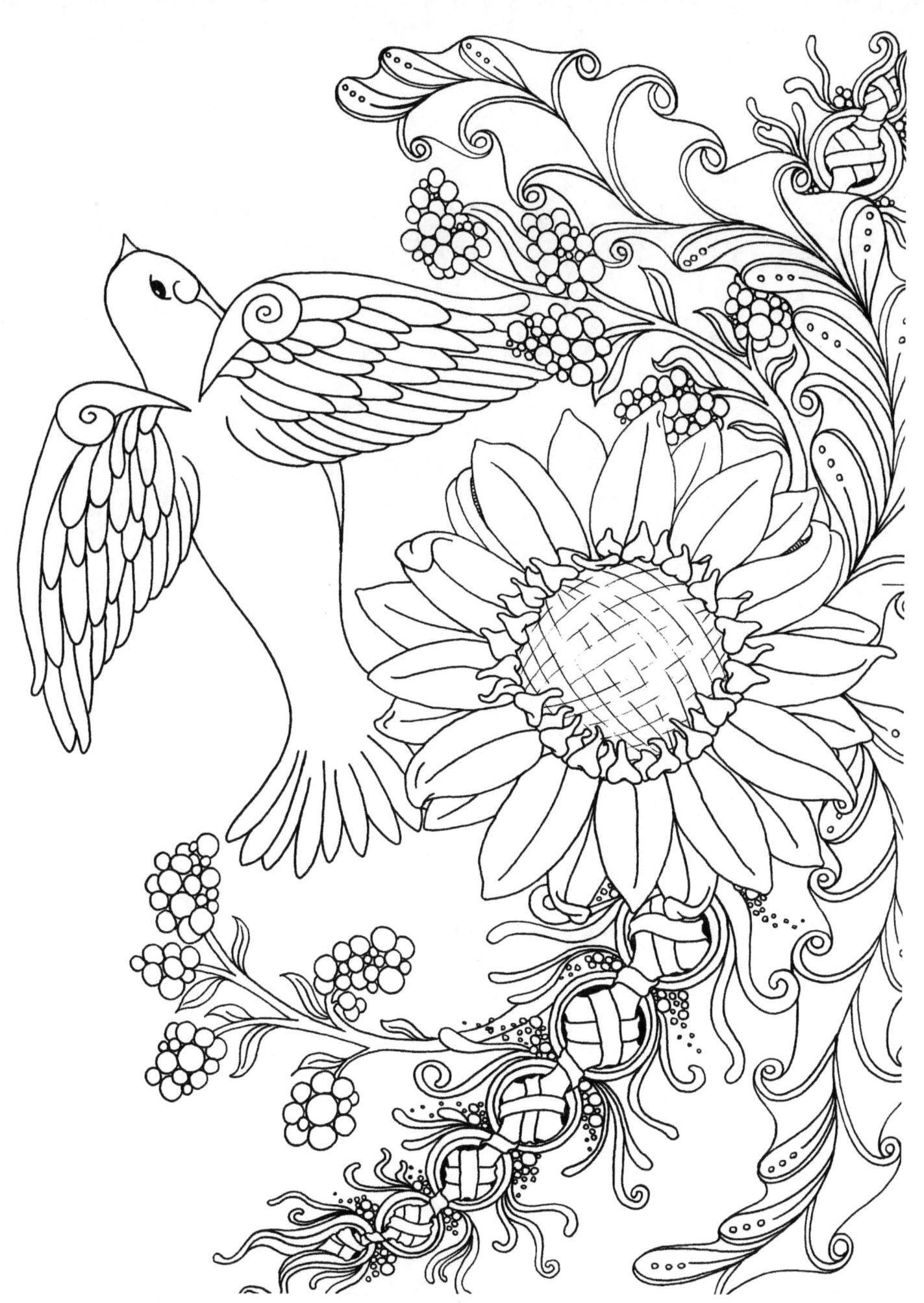

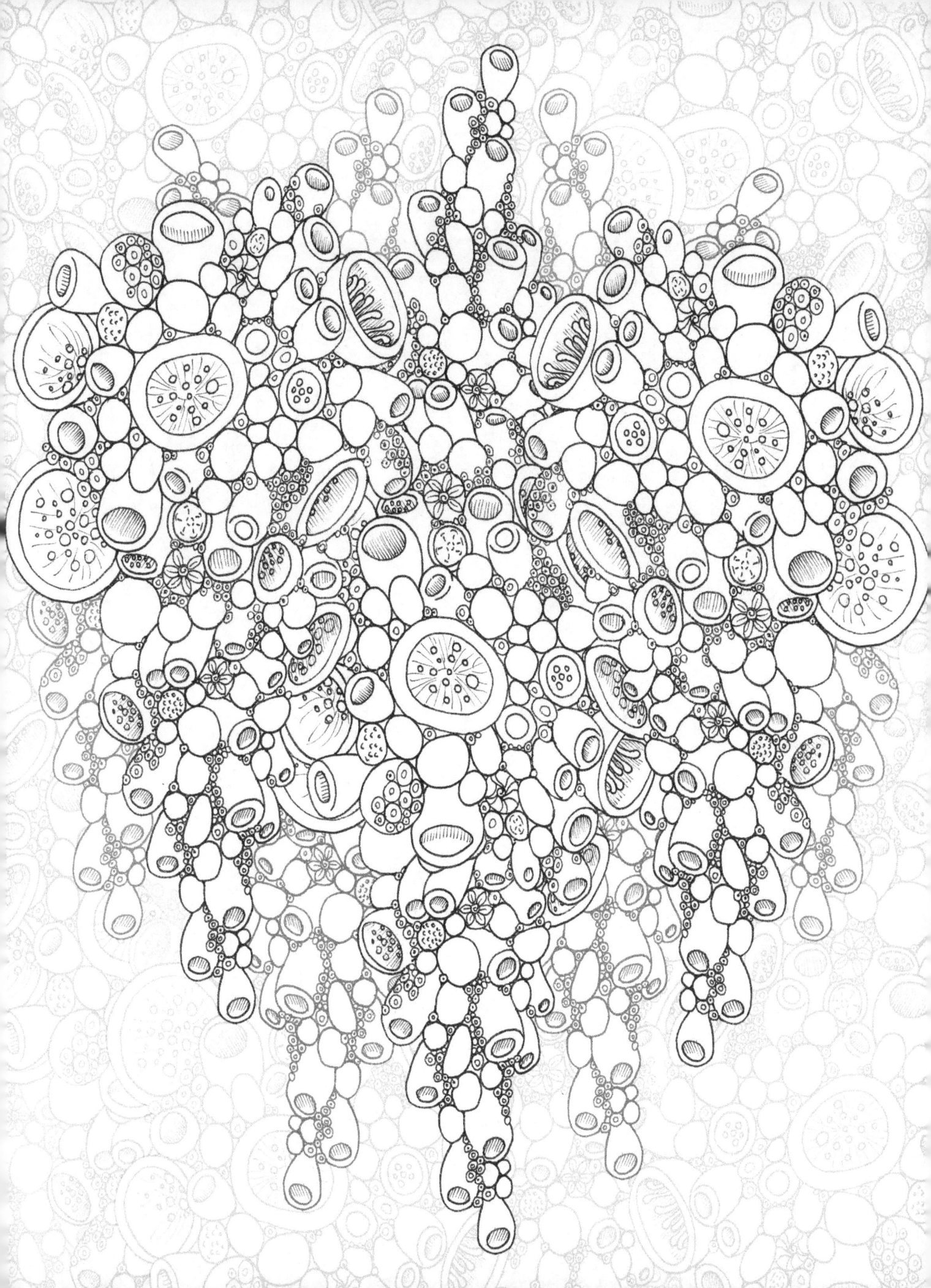

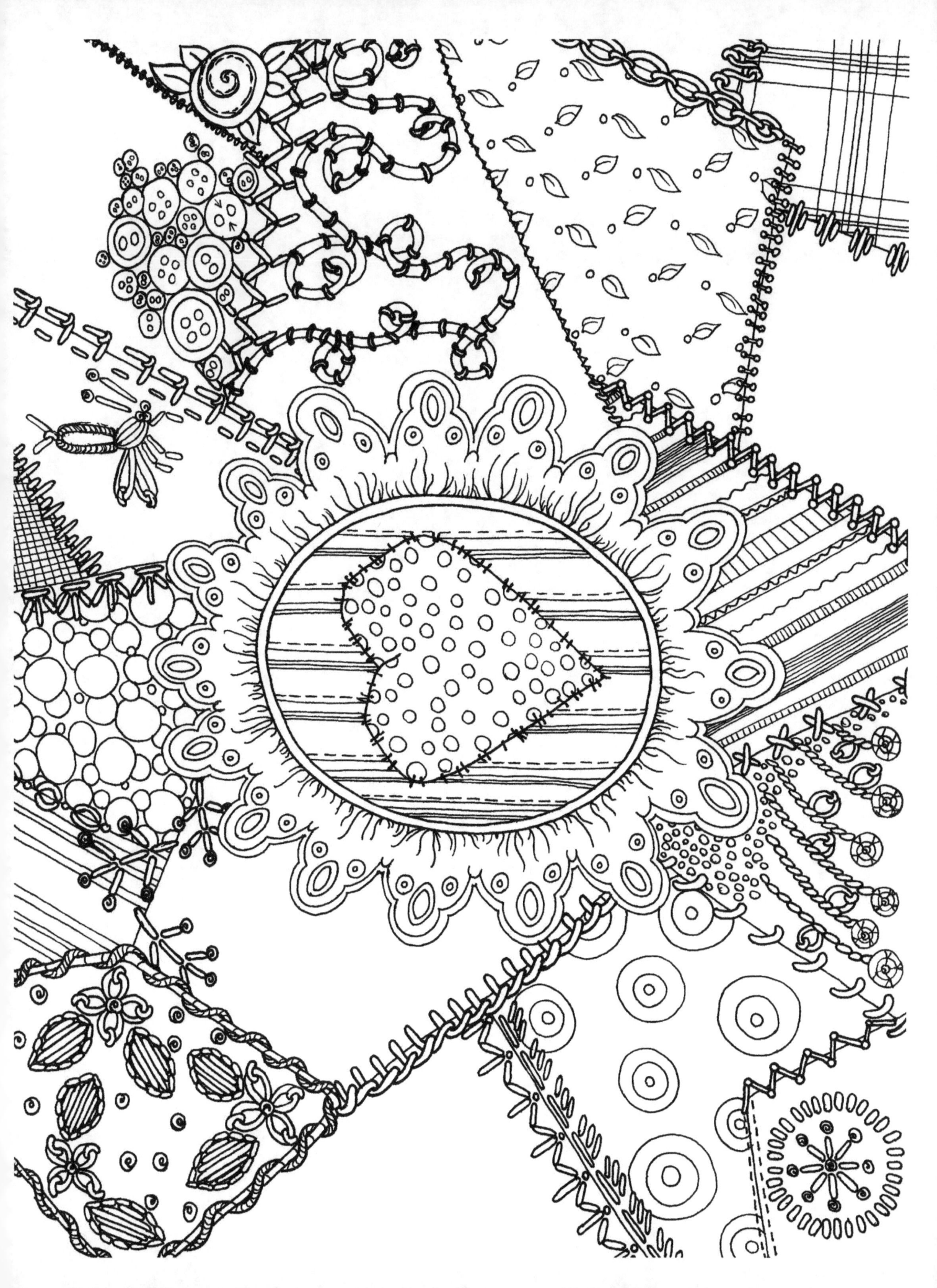

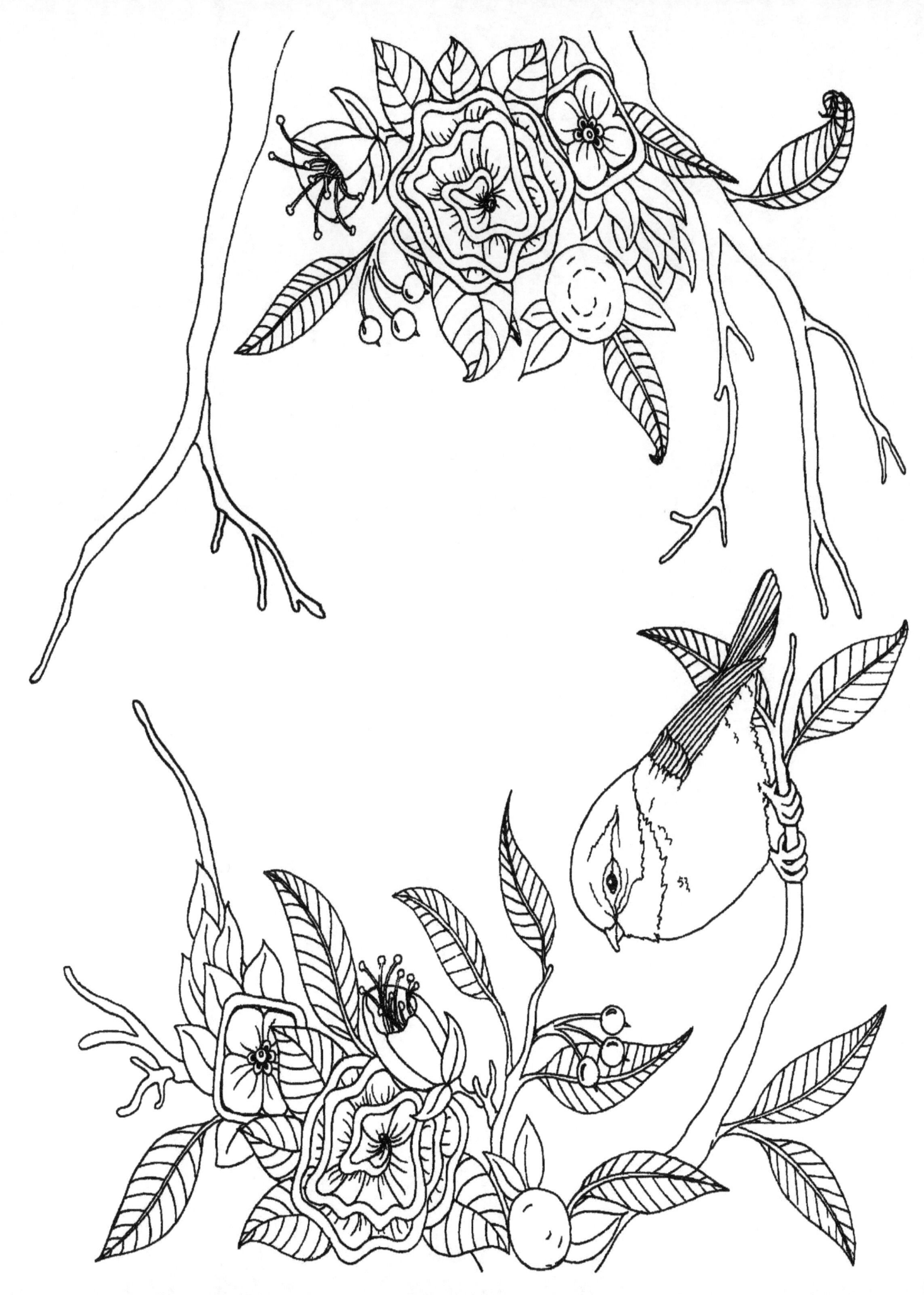

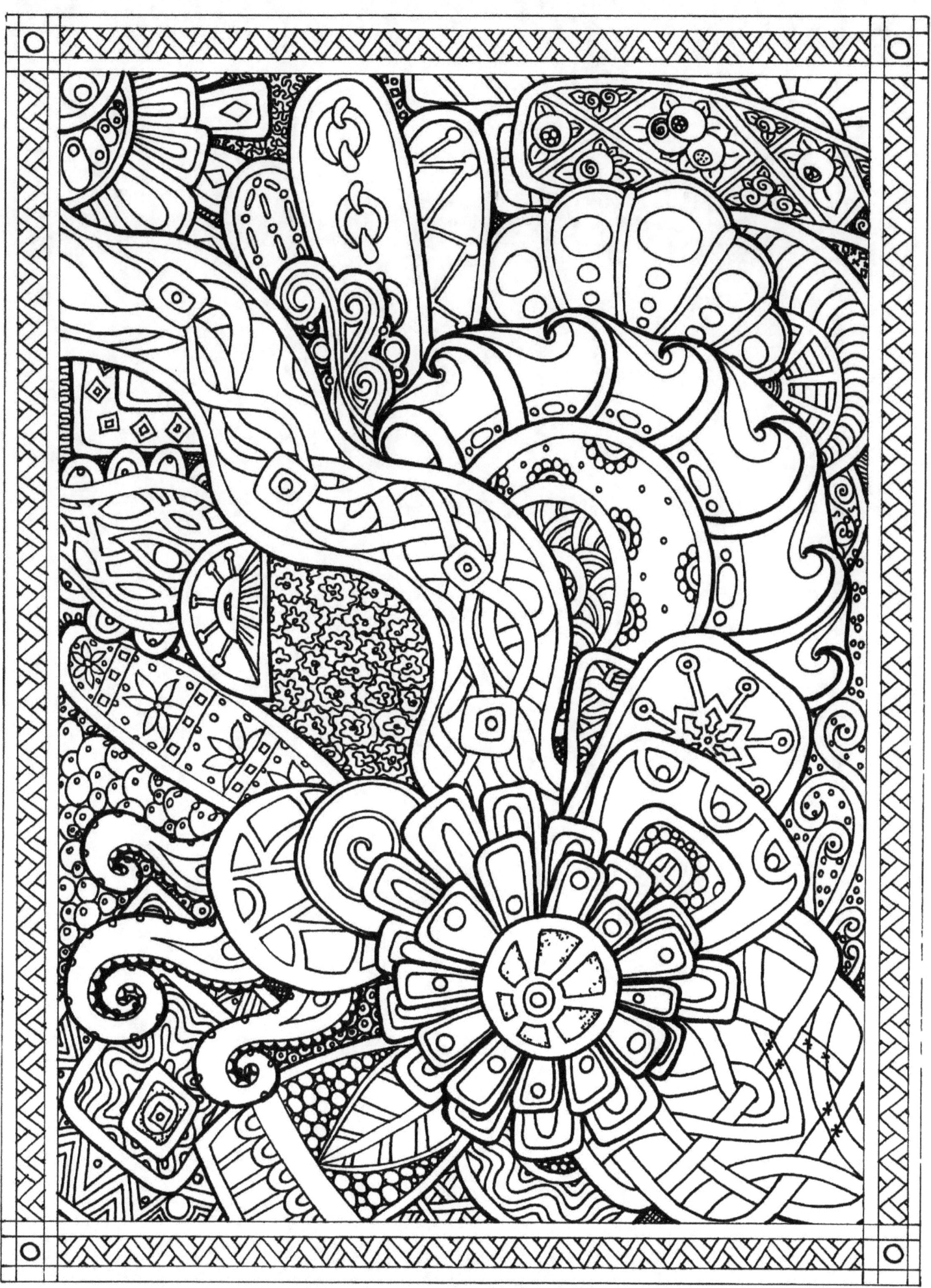

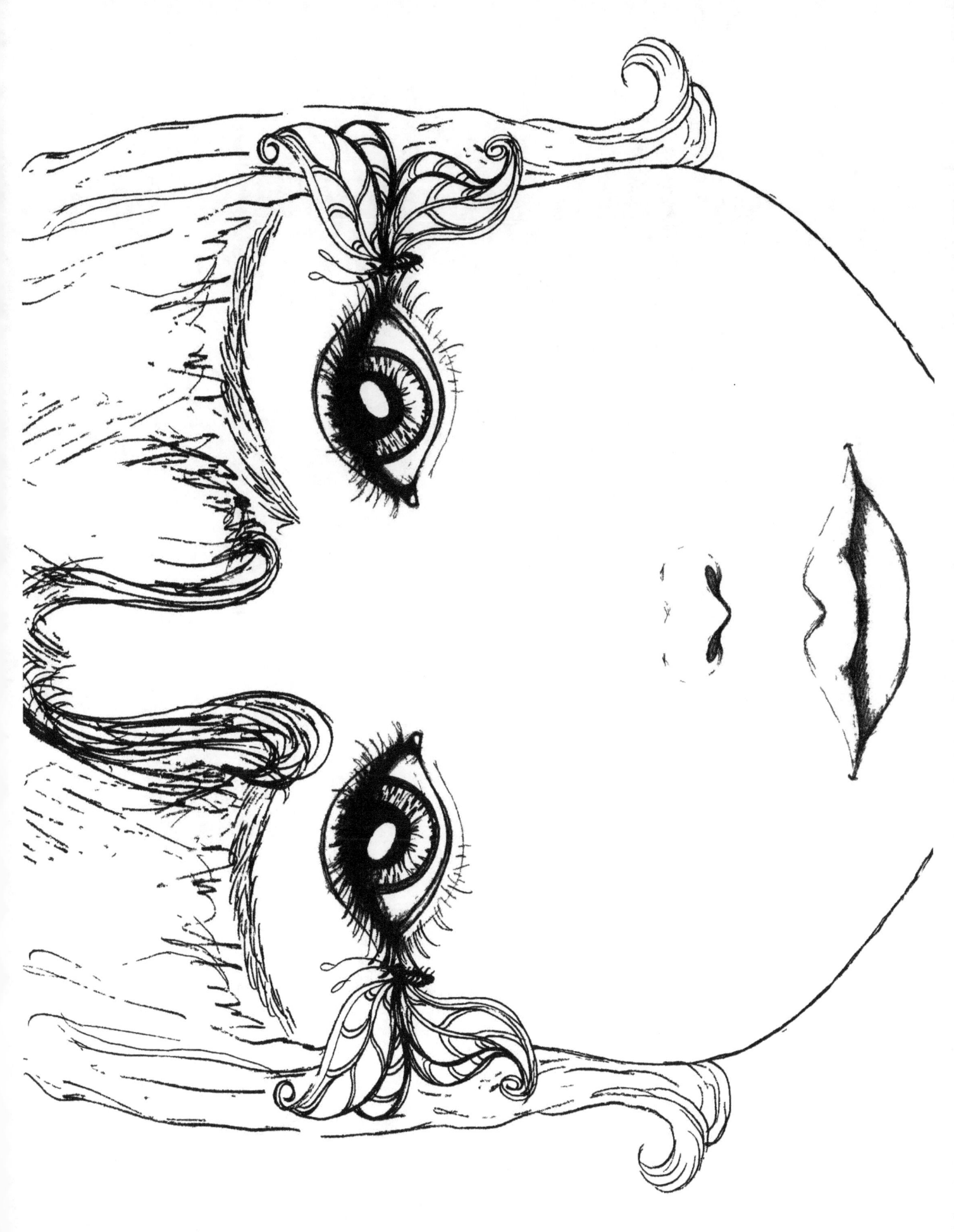

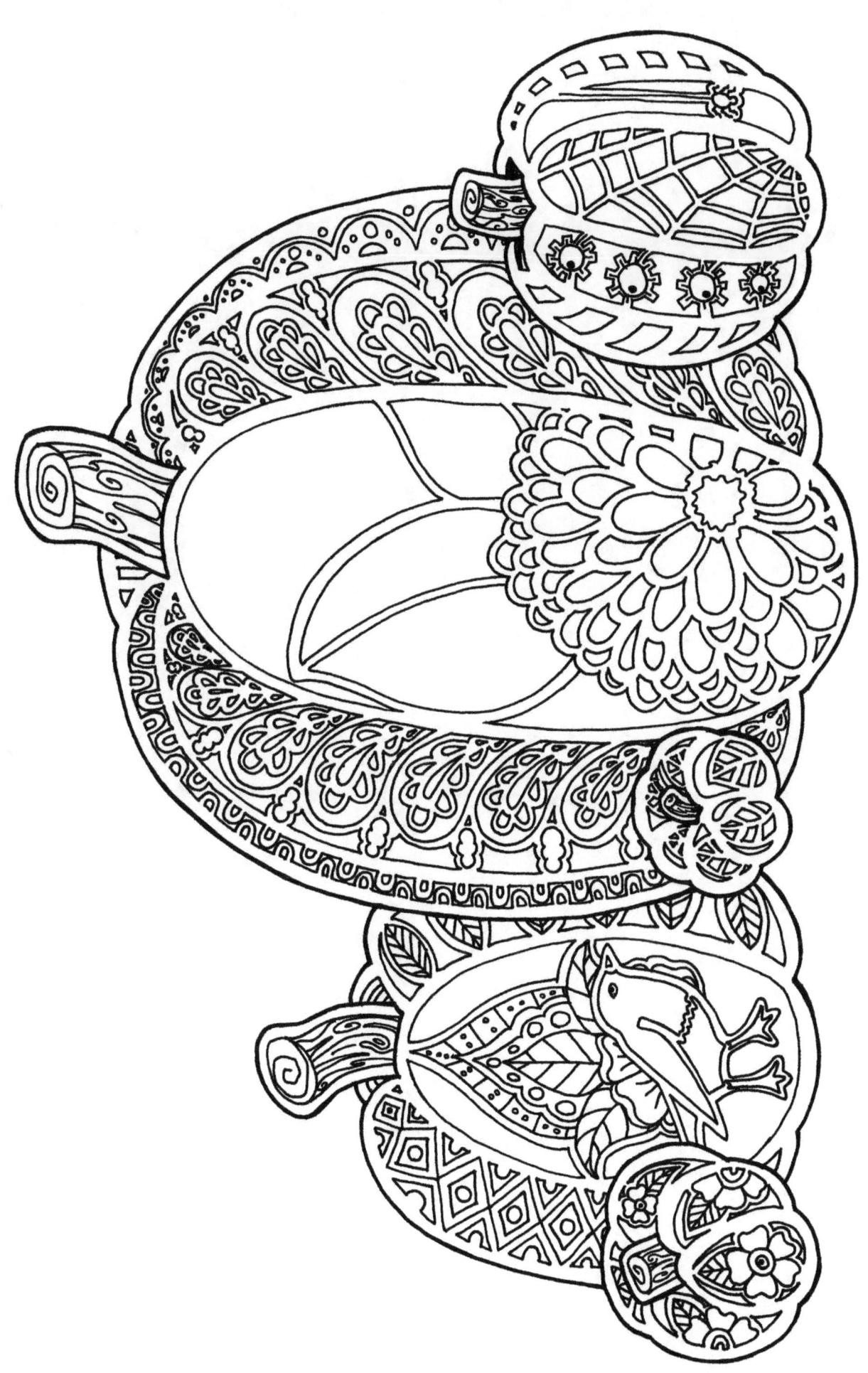

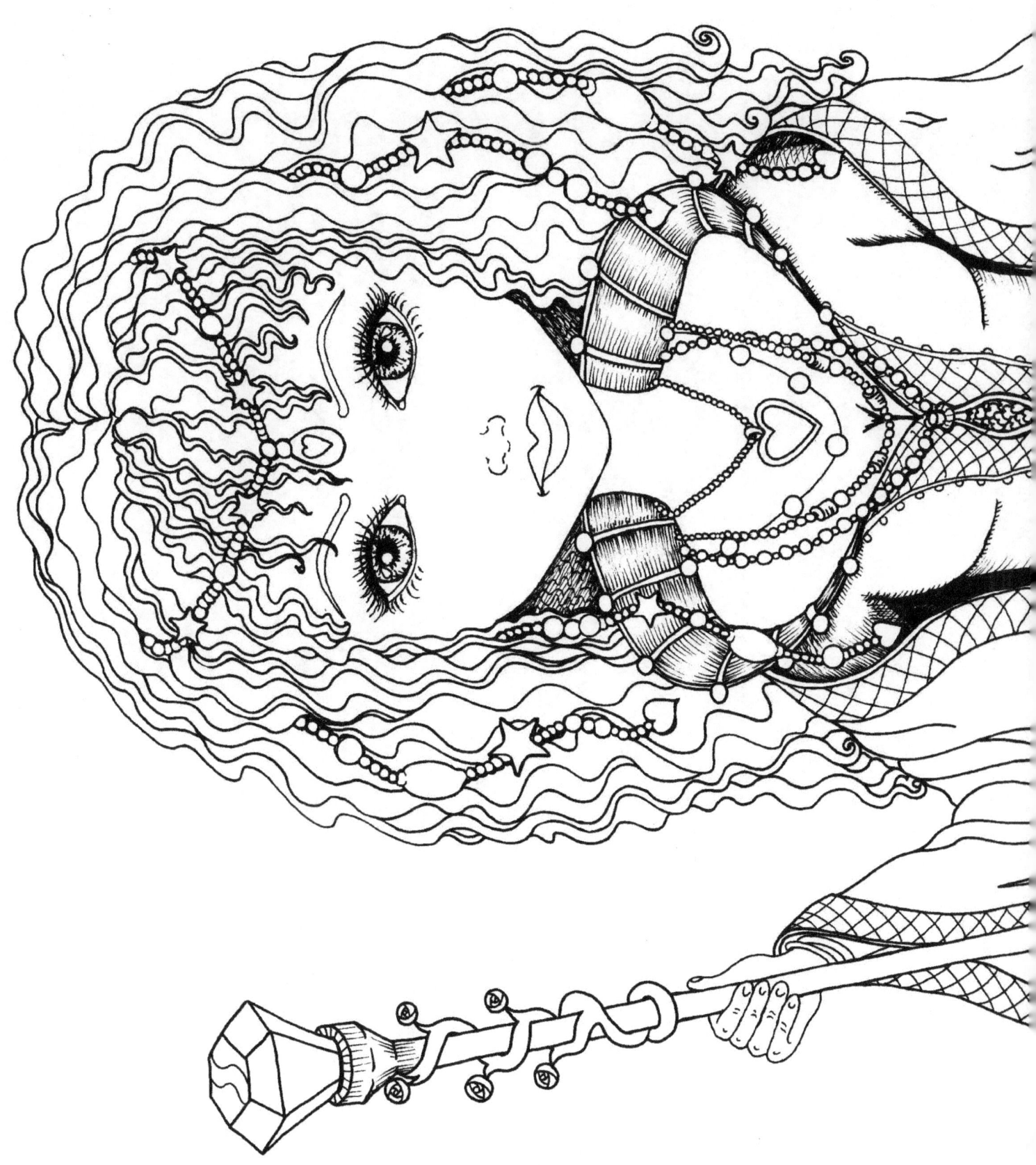

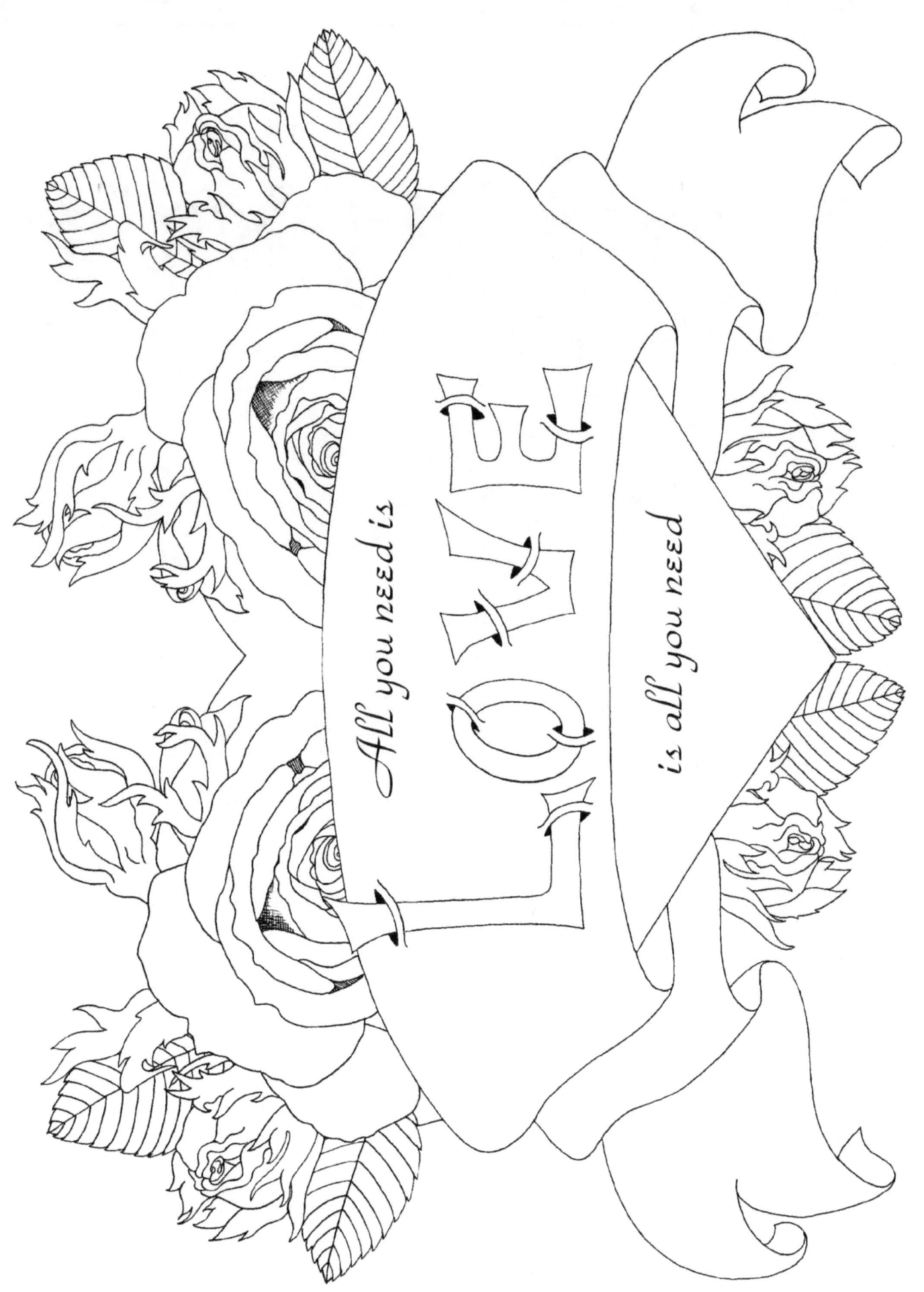

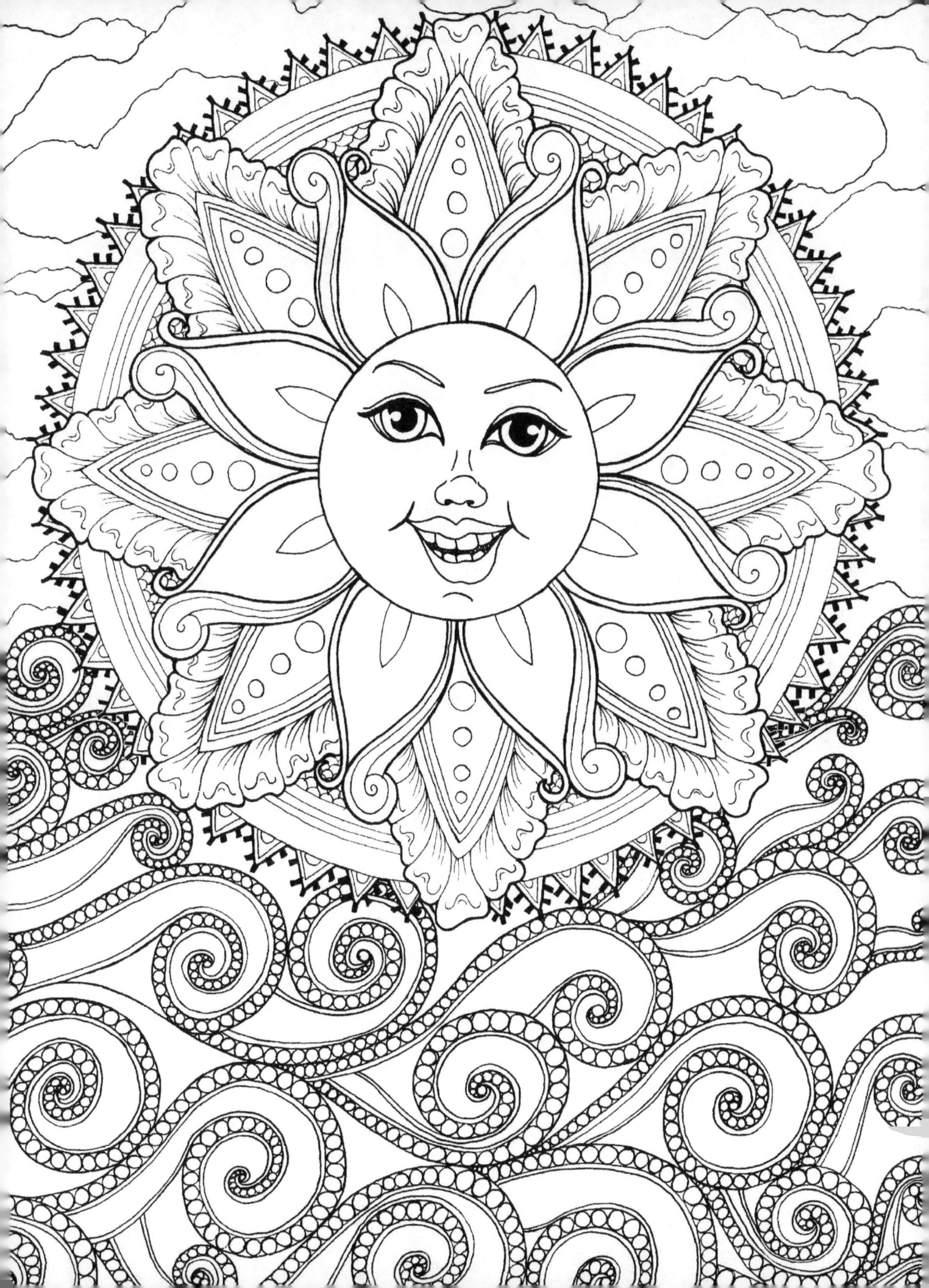

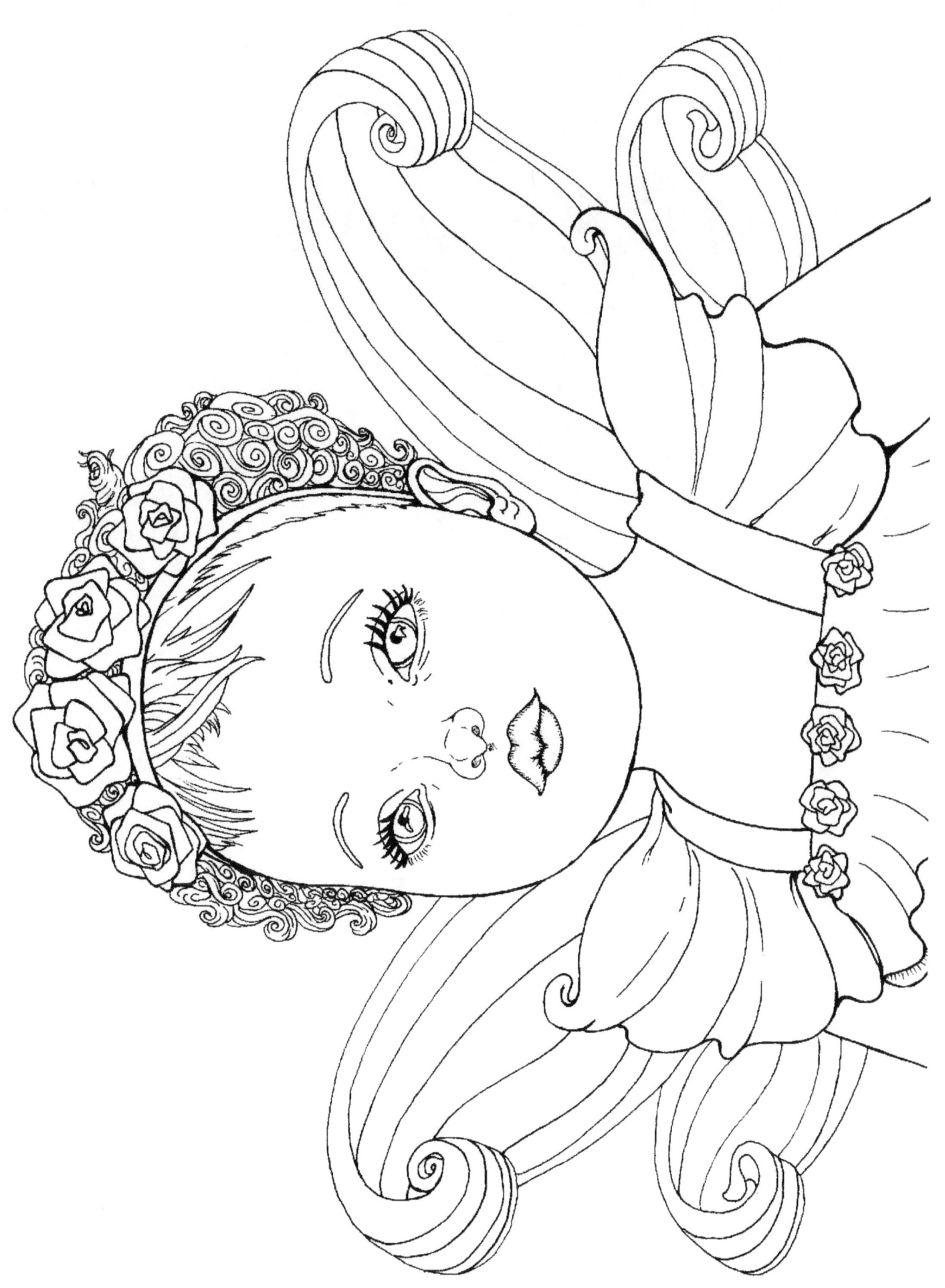

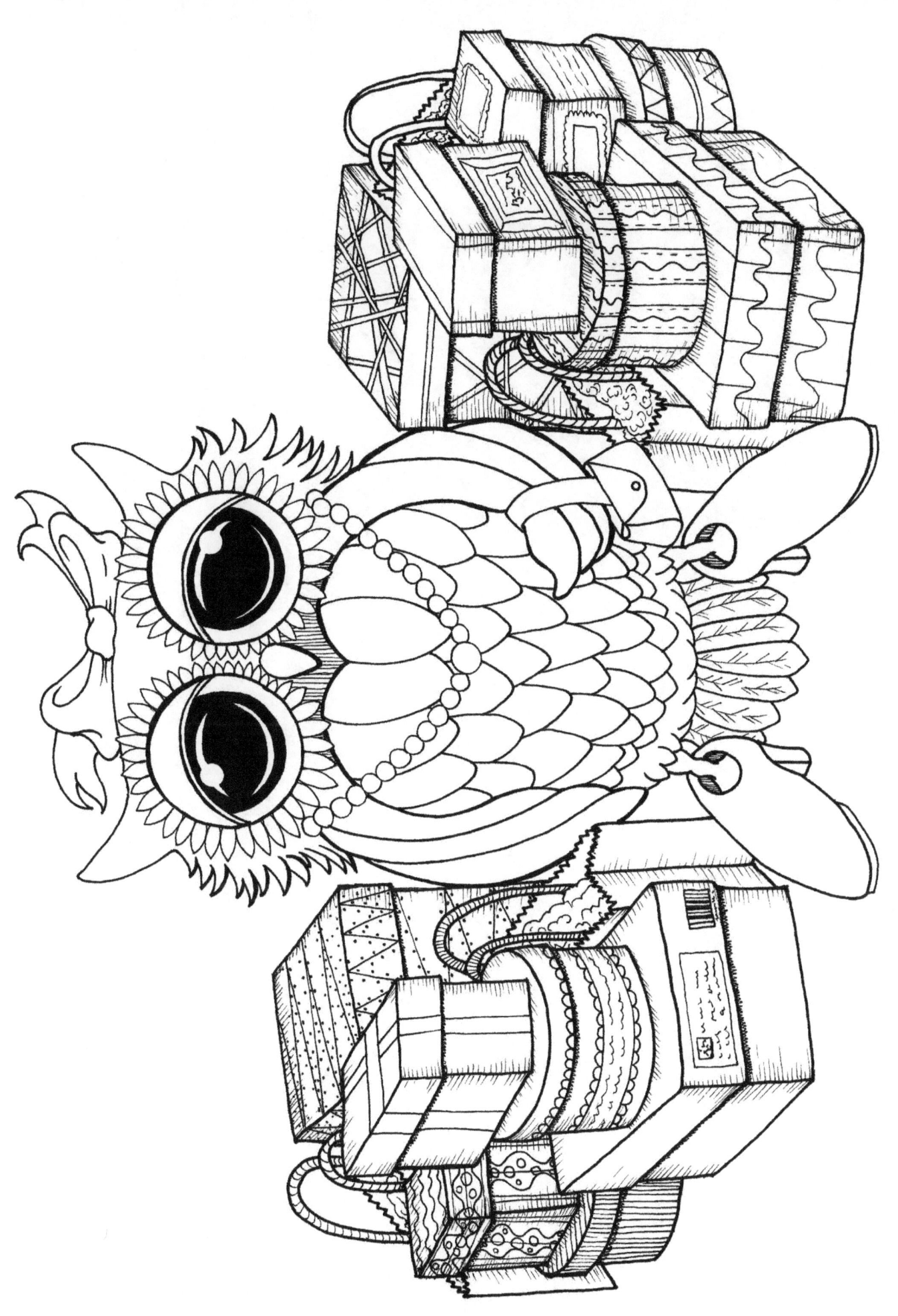

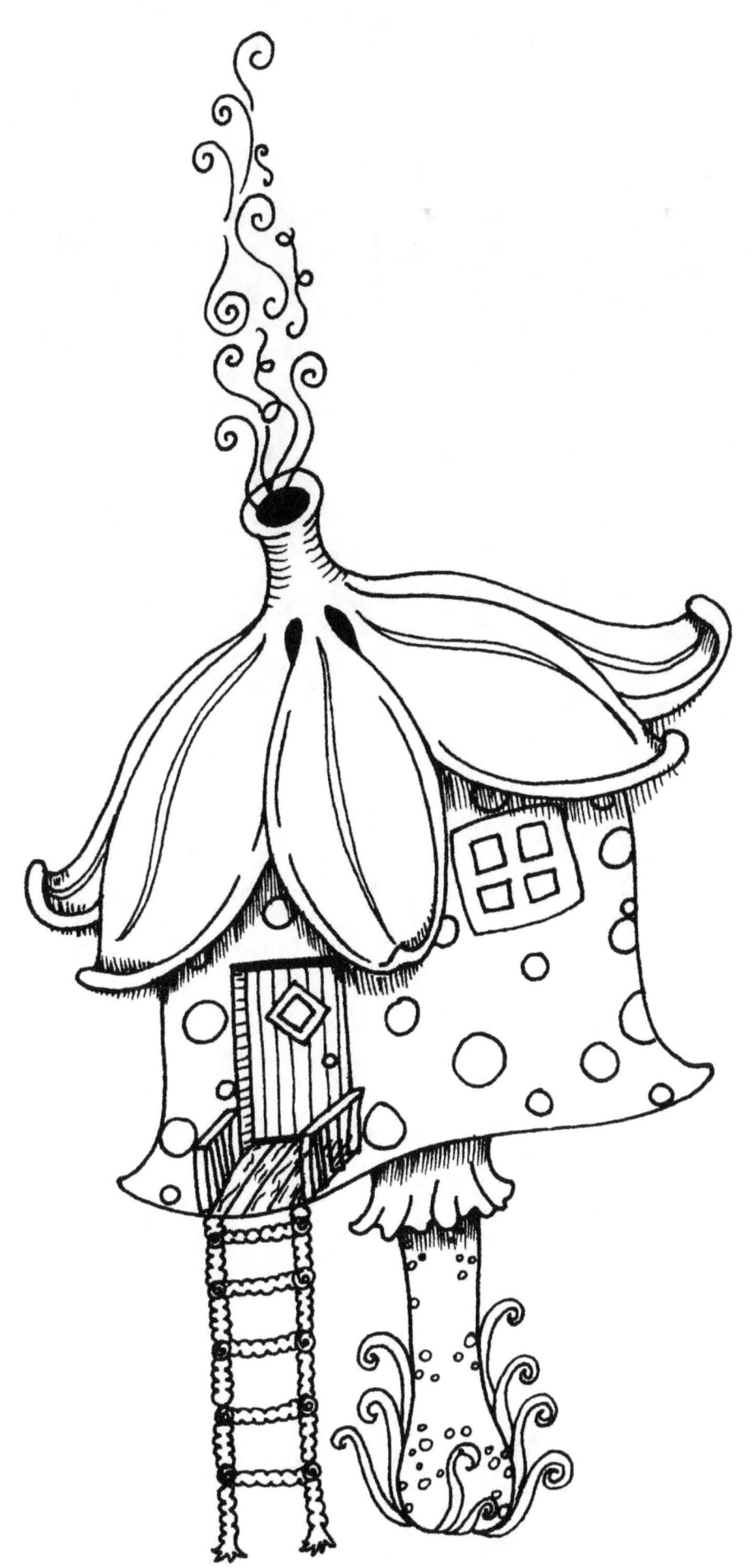

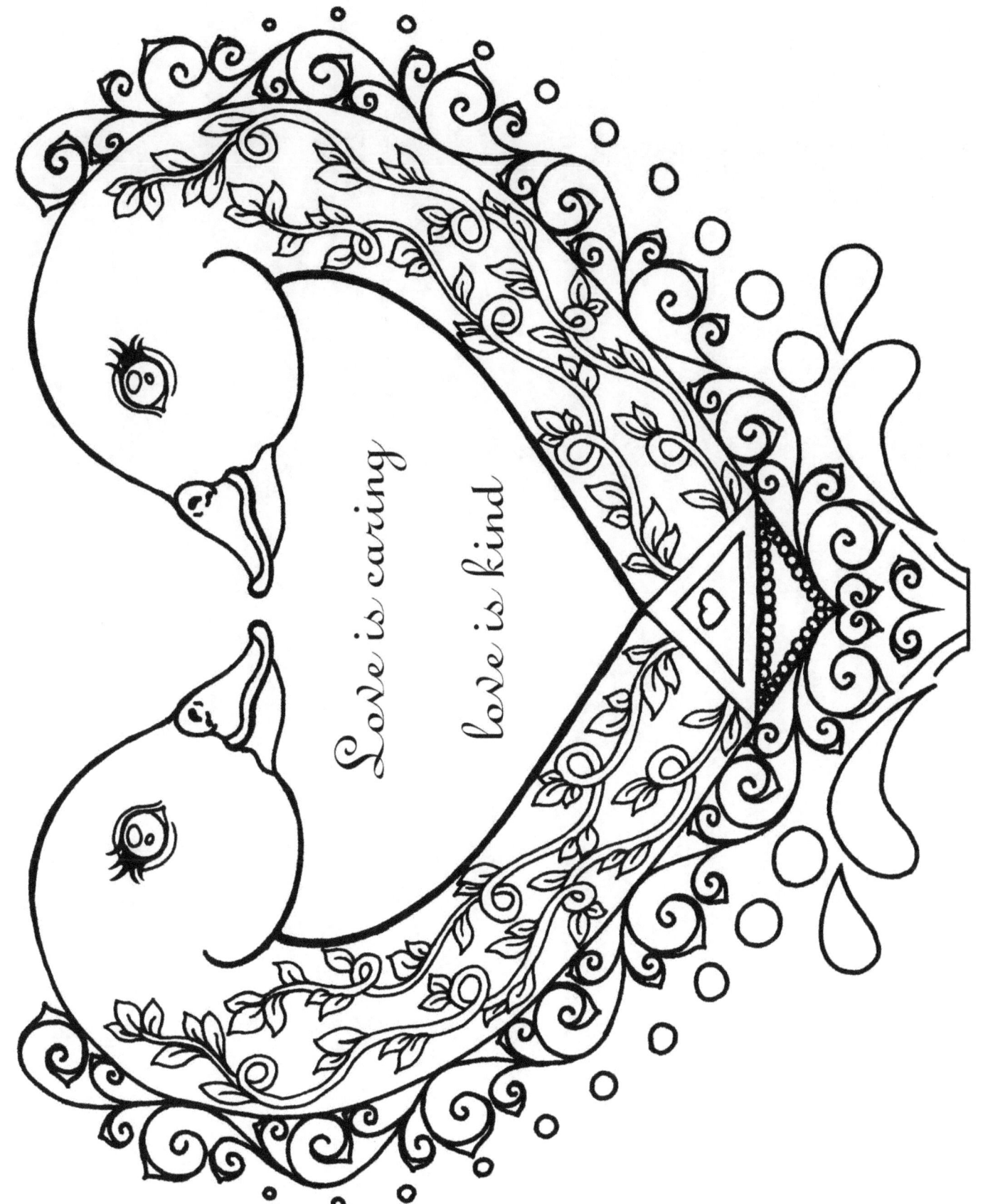

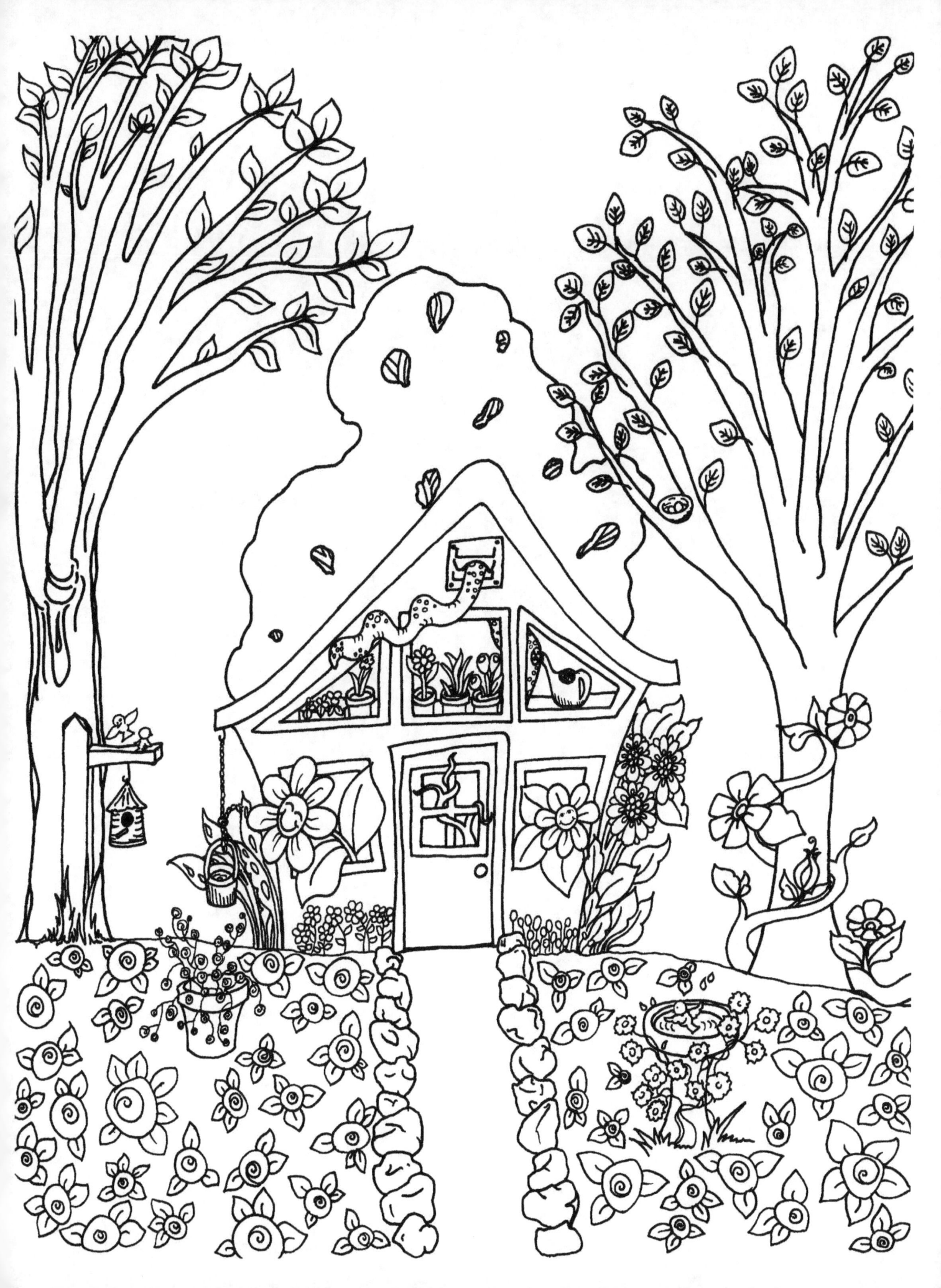

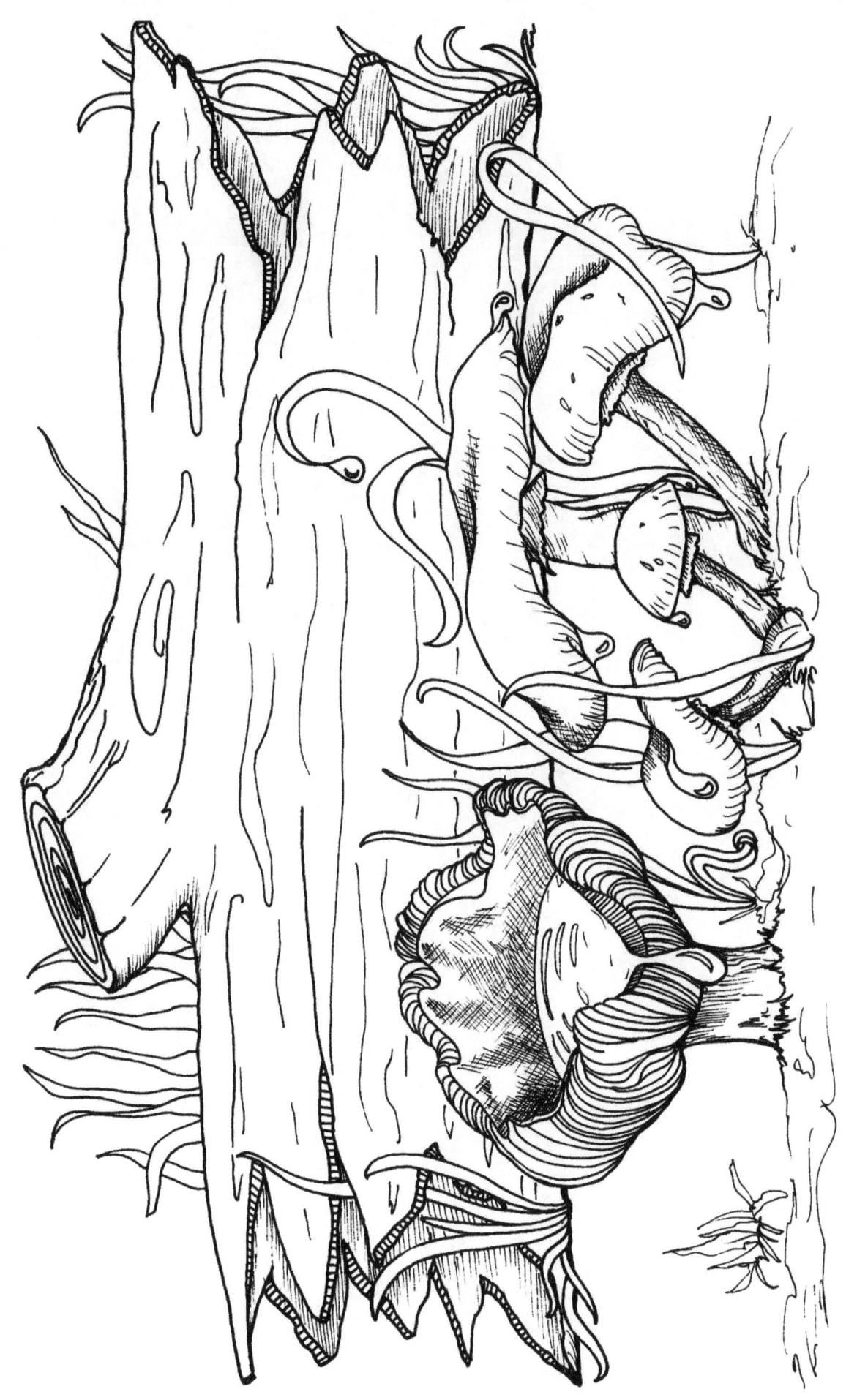

Zen henna tanga doodle

presents

Guest Artist

ALEXANDRA KEMPHER

"Artists are just children who
refuse to put their crayons down"
- Al Hirschfield

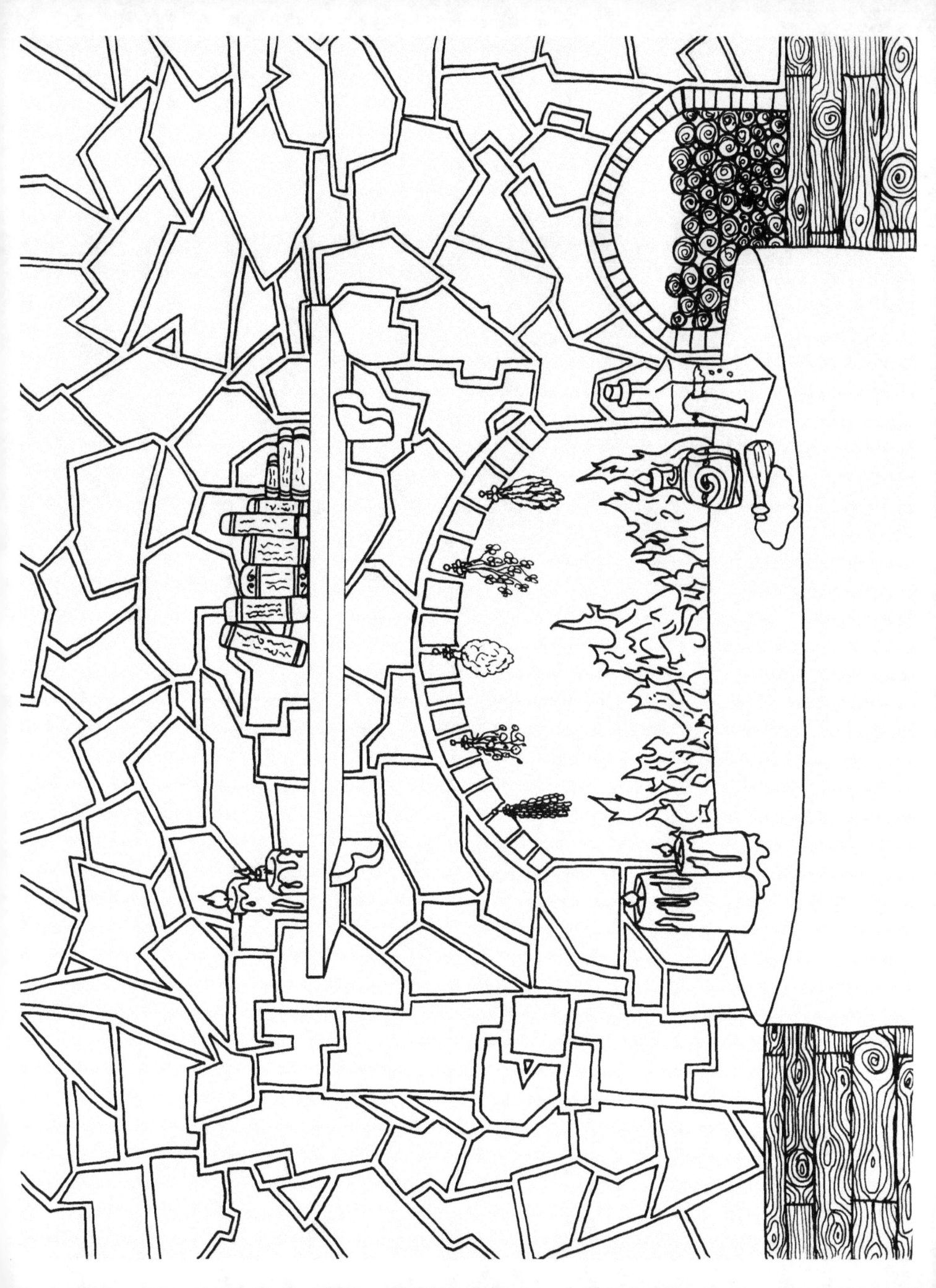

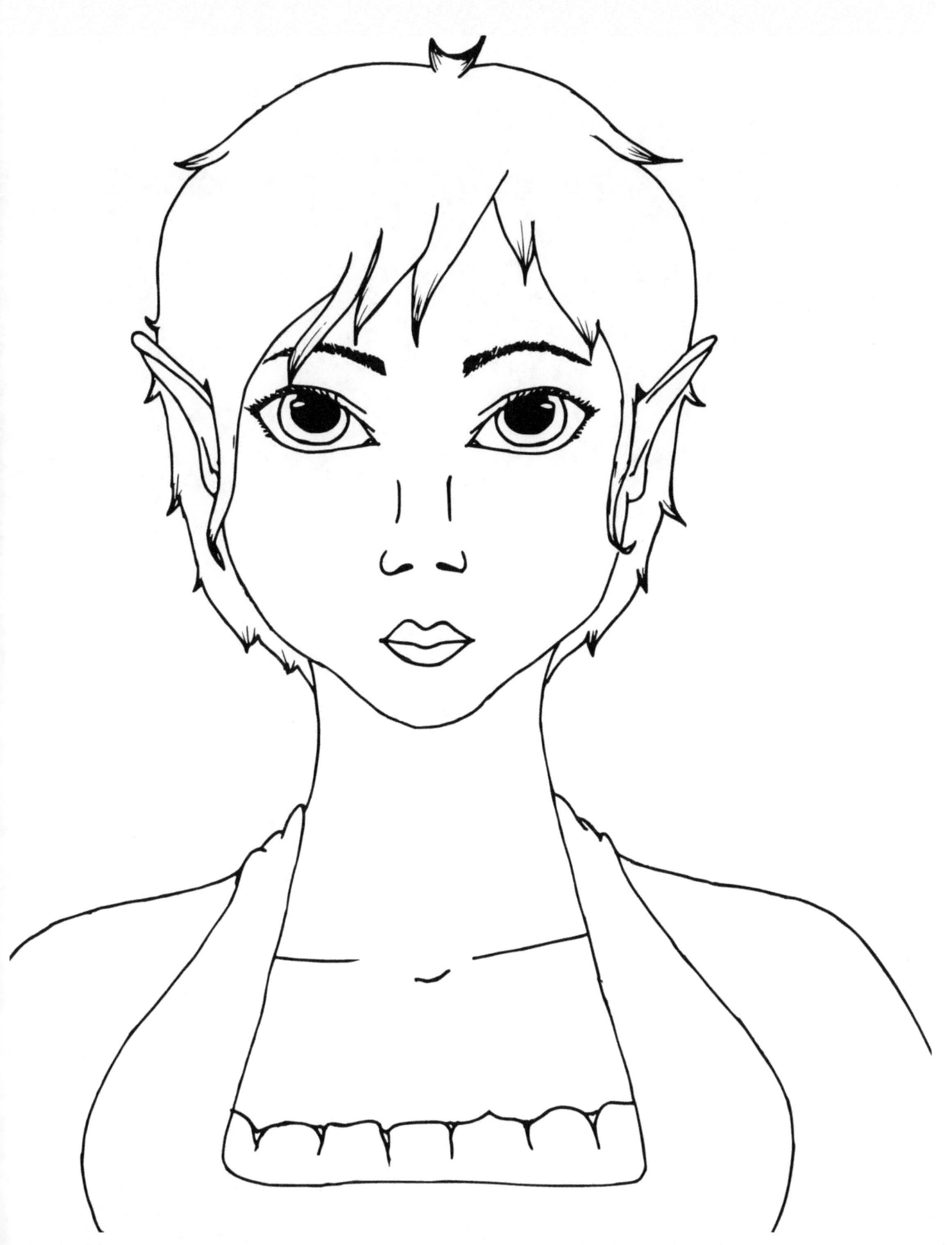

DIY

Foam-Board Pencil Box

by
Jamie Taylor

Directions to DIY the Foam-board Pencil Box
22*1/4" tall x 14*1/2" wide x 9*1/2" deep

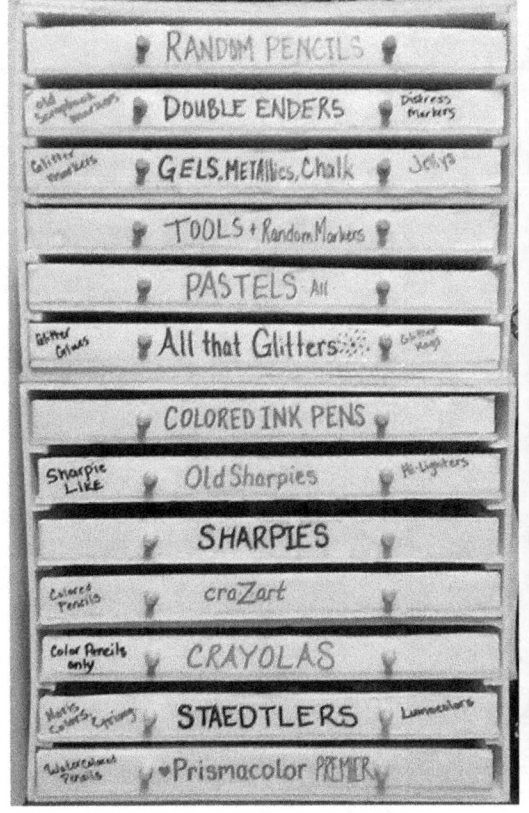
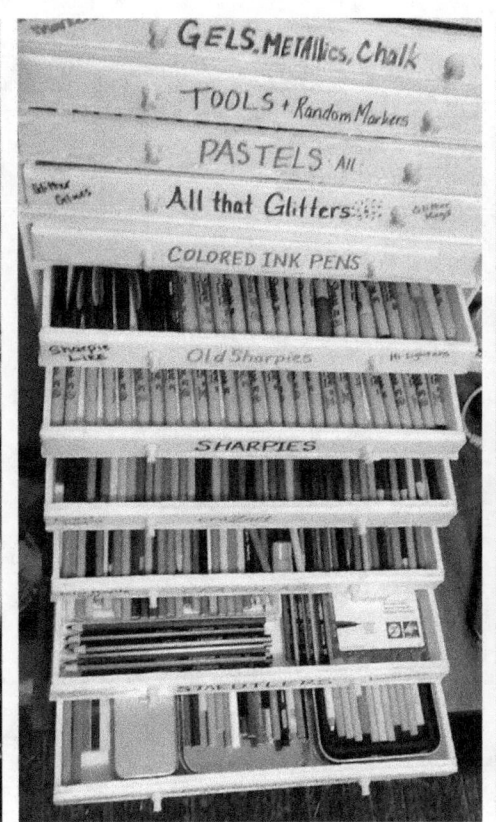
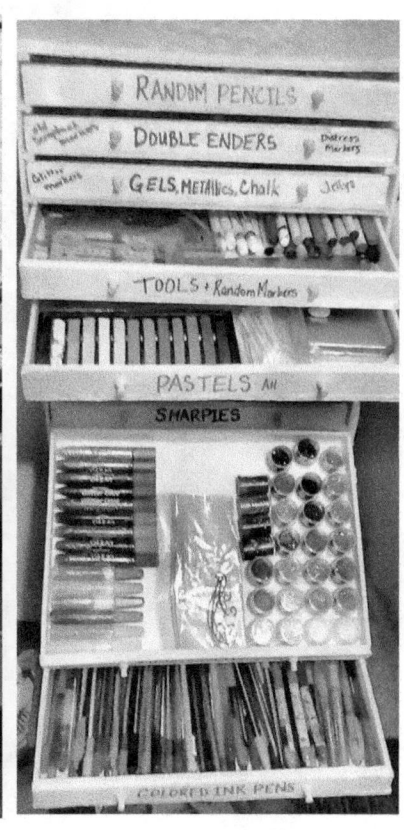

What you will need: (for the 13 drawer box) adjust as you see fit

9 sheets of poster board size foam-board (I paid $1.19 each)
A craft or utility knife
A yard stick & a ruler
A pencil
One bit of scrap paper about 1/2"x 4" (to make the drawer pulls)
Package of wooden thumb tacks- you will use 26 of them (under $3.00)
Hot glue and hot glue gun (I used 40 mini sticks- $4.00 ish)
Be careful, hot glue is HOT and can burn you

CUTS: Cut all parts first (lightly write the part number on all pieces)

Part Af and Ab ** 39 pcs at 13*1/2" -fronts and backs of drawers, mark 26 as AF and the last 13 as Ab
Part B ** 26 pcs at 8*7/8" - sides of drawers
Part C ** 13 pcs at 9*1/2" x 13*1/2" -drawer bottoms
Part Dr and Dl ** 26 pcs at 8*3/4" x 1/2" -drawer braces, mark 13 as Dr and 13 as Dl
Part E ** 2 pcs at 9*1/2" x 22*1/4"- sides of box
Part F ** 1 pc at 22*1/4" x 14*1/2" - back of box
Part Gt and Gb ** 3 pcs at 14*1/4" x 9*1/2"- tops and bottom of box, mark 2 as Gt and the other as Gb

Start with your Part Af's, you should have 26. Glue them together in sets of two so you end up with 13 parts. Take your first Part C (drawer bottoms) and glue 1 part Af to the long side of the drawer bottom. Glue 1 Part Ab to the other long side of the drawer bottom. Glue a part B into each short side. Should look like a drawer at this point! Now do 12 more just like it!

Glue together the 2 Part Gt's the box top. Lay out Part E and glue the Gt (now one pc) to the edge. Glue Gb to the other ends edge. It should look like a long U at this point. Now take the other part E and glue it to the edges of the Gt and Gb. You should have a square. Make sure that your Part F, the back of the box, is cut very straight, this is what will make your box even and stable. Set your glued parts with an open side up and start gluing the back (part F) to the square. Give the glue a few seconds to dry then stand it up tall.

Continue DIY Foam-board Pencil Box

The next thing we are going to do is measure out where the braces for the drawers go (parts Dr and Dl). To correctly fit the drawers I suggest you use each drawer to make it off as the straightness of your cuts can change the dimensions. I laid eac drawer in, one at a time and made a light mark with my pencil along the top of each side of the drawer and added an 1/8th of an inch to that then glued the braces just above that line. Leaving that drawer in place, do the same with your next until you have them all in place. You can also measure the space inside the box and divide it by the amonut of drawers and glue your braces at that measurement.

The next step is the drawer pulls (thumb tacks). With the scrap of paper mark it off and 1/4 inch down the length (the center), and from one end of the scraps paper measure in 3*1/4" and make a dot on the center line at that point. Take one of your tacks and poke a hole in that spot. Now on the right sides of all the drawers lay that scrap paper on each drawer and make a pencil make thru that poked hole. Flip the paper over and do the left side now, same way. Put a tiny dap of hot glue on you thumb tack and poke it into that DOT on each side of the drawer being careful not to push it all the way thru the drawer front. (if you do get one that goes all the way thru just put a dab of hot glue on the tip so it doesnt jab you on accident.)

Last but not least! Decorate your box!

Come visit me on Facebook at
https://www.facebook.com/Zenhennatangadoodle

Check me out on:
Amazon
CreateSpace
Barnes and Noble
and more online book stores!

www.ingramcontent.com/pod-product-compliance
Lightning Source LLC
Chambersburg PA
CBHW080659190526
45169CB00006B/2183